CAJUN COFFEE
FOR
SENIOR CITIZENS

CAJUN COFFEE FOR SENIOR CITIZENS

LEROY THIBODEAUX

Copyright © 2012 by LEROY THIBODEAUX.

Softcover 978-1-4797-0905-2
Ebook 978-1-4797-0906-9

All rights reserved. No part of this book may be reproduced or transmitted in any form or by any means, electronic or mechanical, including photocopying, recording, or by any information storage and retrieval system, without permission in writing from the copyright owner.

This book was printed in the United States of America.

To order additional copies of this book, contact:
Xlibris Corporation
1-888-795-4274
www.Xlibris.com
Orders@Xlibris.com
121825

LIFELIKE CARTOONS...
WITH ONE LAUGH AFTER THE OTHER FOR YOU

EVERYONE KNOWS A SENIOR CITIZEN CAN ASSOCIATE THE CHARACTERS IN THIS BOOK WITH . . . A GRANDPARENT, DEAR AUNT OR UNCLE, OR JUST THE SWEET LITTLE COUPLE WHO LIVES DOWN THE STREET. THIS HUMOR IS FRESH AND APPEALING.

CREDITS AND APPRECIATION

I would like to give proper credit to Ira Fontenot, prior owner of Lane's Drug store in Vinton, Louisiana. He told me about some of the sources of humor that he heard in the coffee shop...old timers telling jokes in Cajun French and English and etc. some of this information gave me "Food For Thought" when I created the cartoons in this book.

I especially thank my wife "Mert", for laughing at my jokes, and encouraging me to put my humor into cartoons.

Finally, special credit and appreciation should go to my son, David, whose mercy doesn't always endure forever when it comes to hearing me tell him jokes that i might or might not use in my book. All these cartoons weren't created overnight. It took a lot of time to create the ideal jokes and characters for each cartoon. I thank him for sharing his opinion and ideas with me.

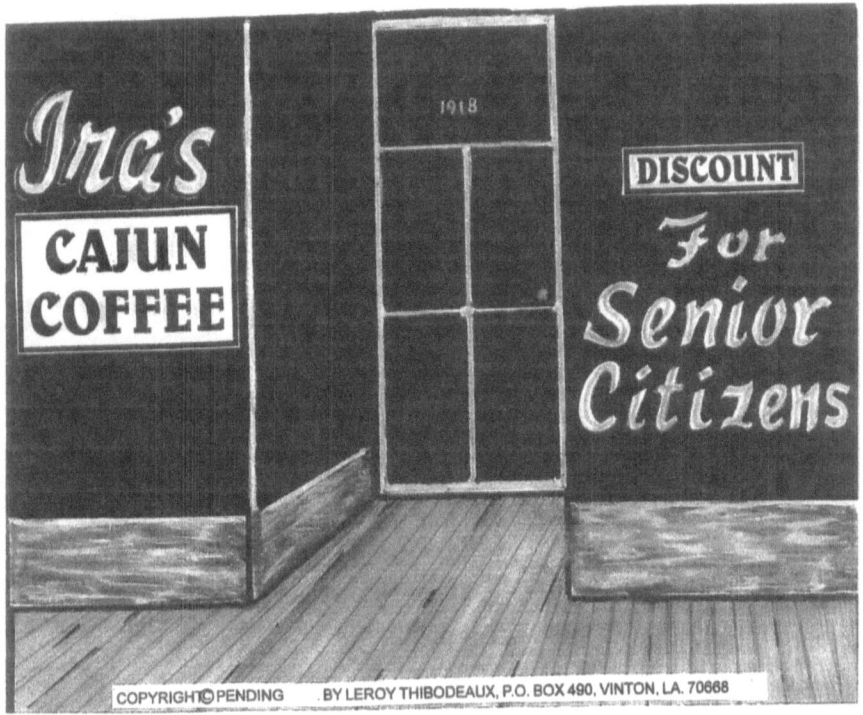

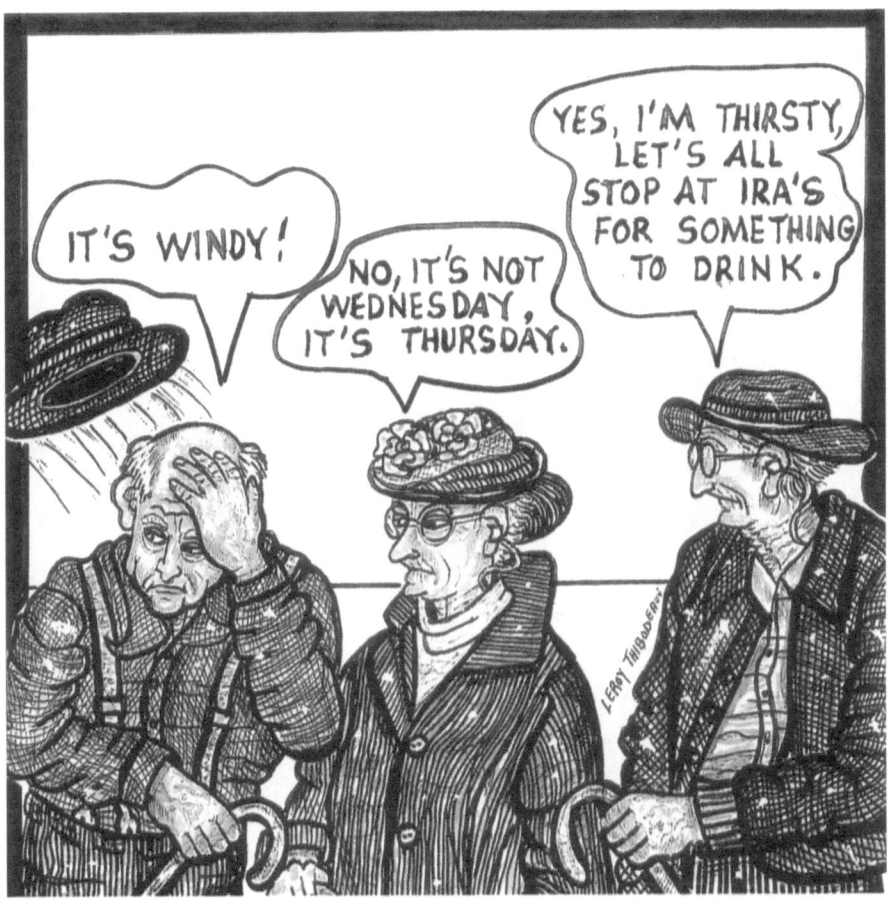

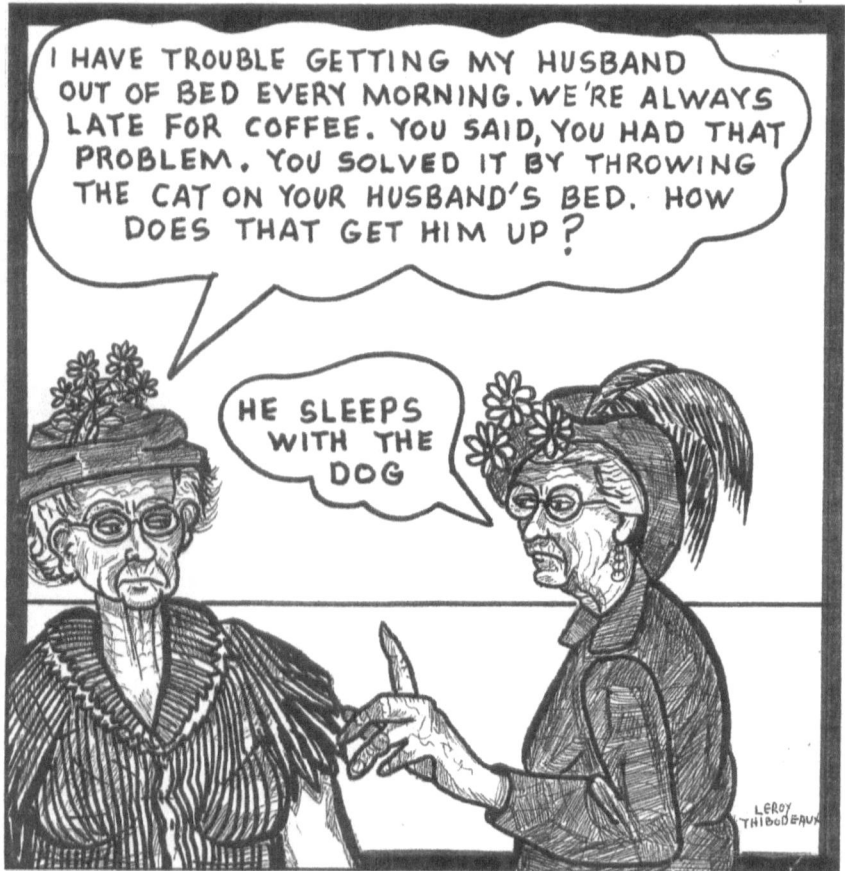

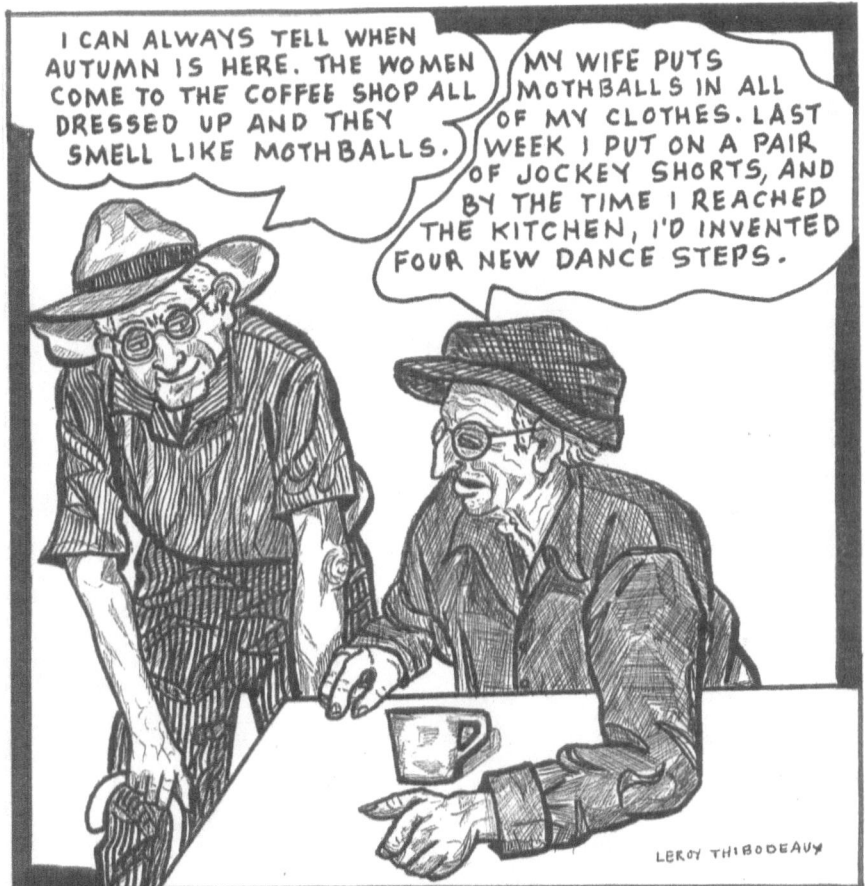

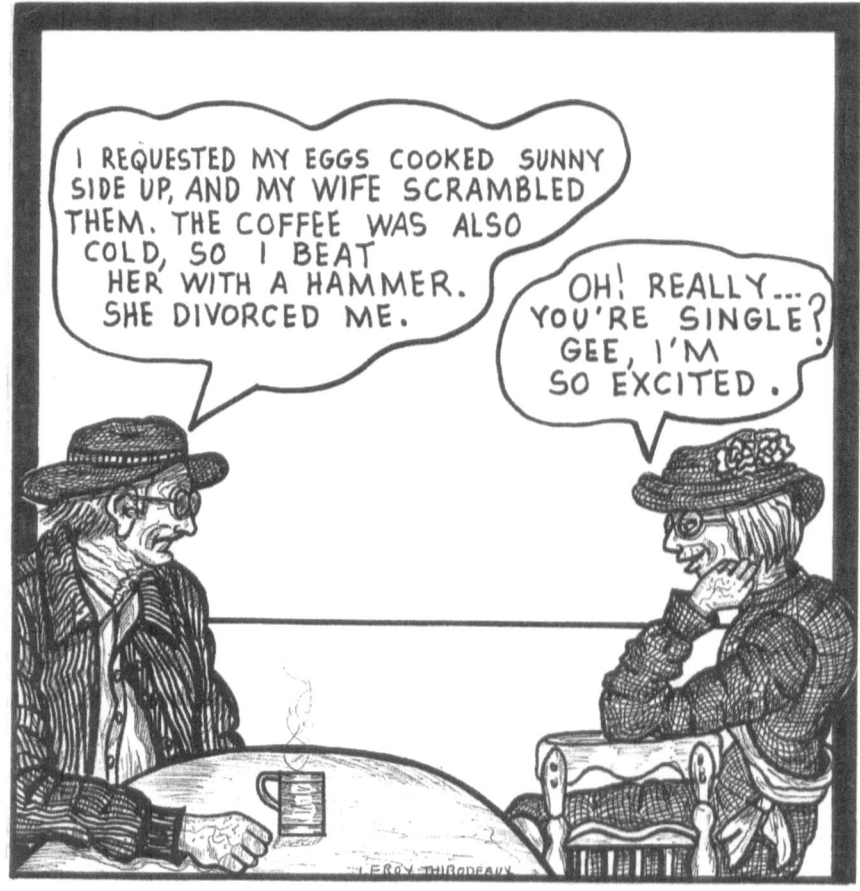

CAJUN COFFEE FOR SENIOR CITIZENS

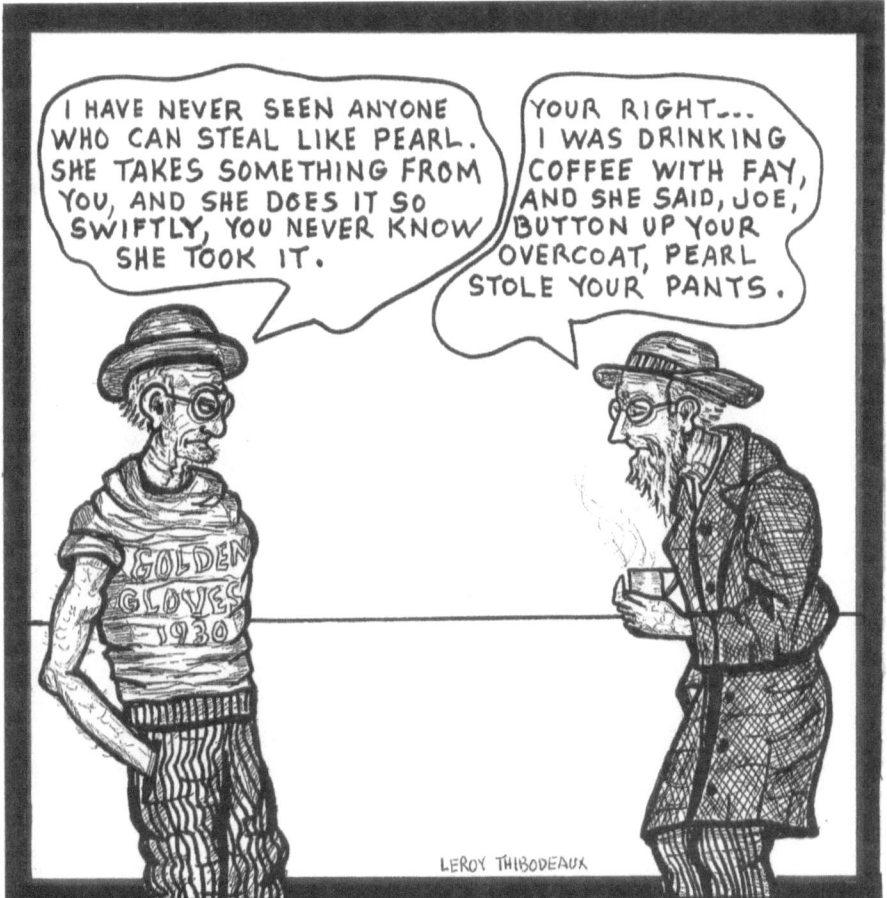

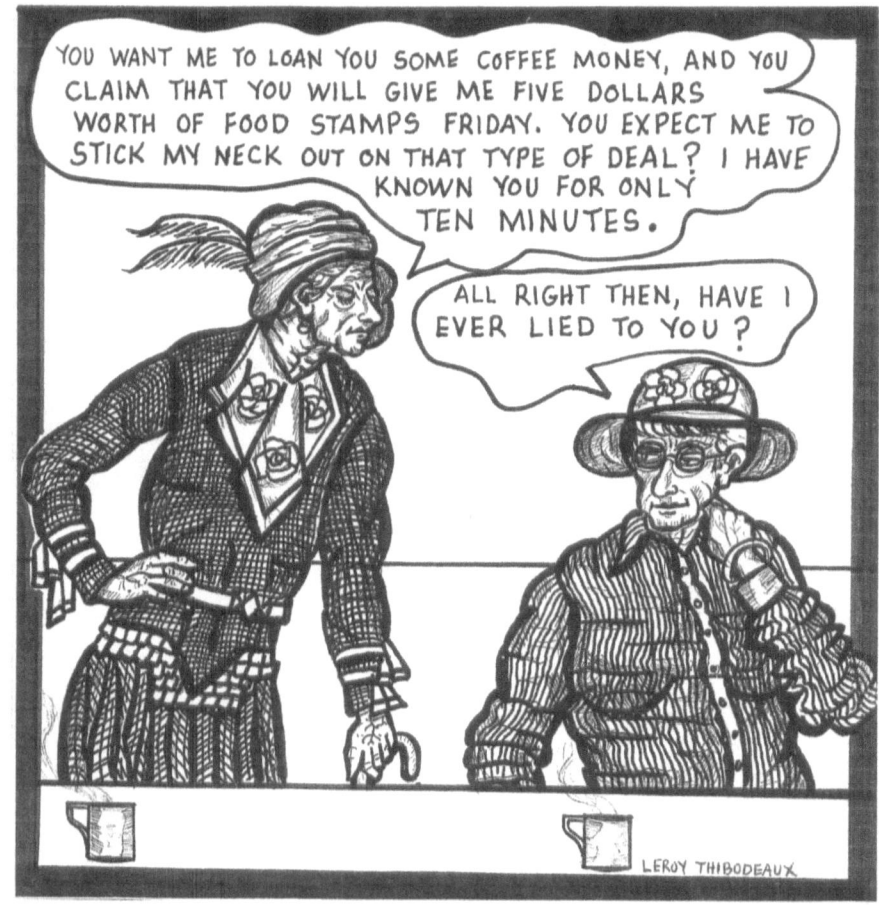

CAJUN COFFEE FOR SENIOR CITIZENS

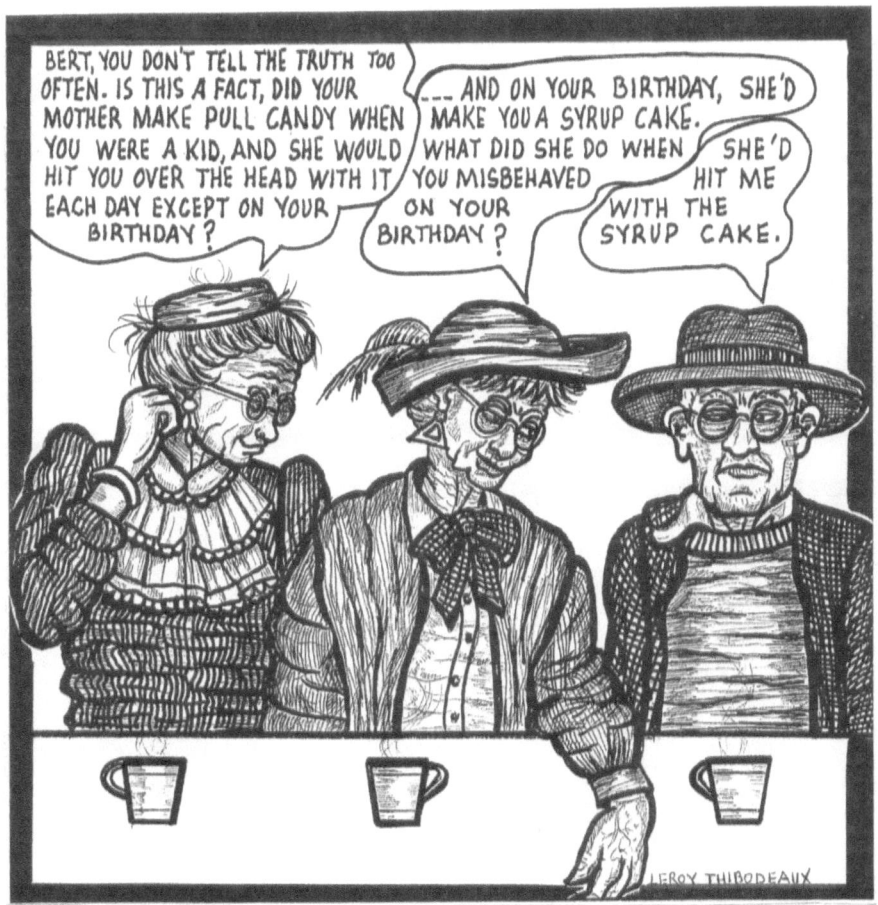

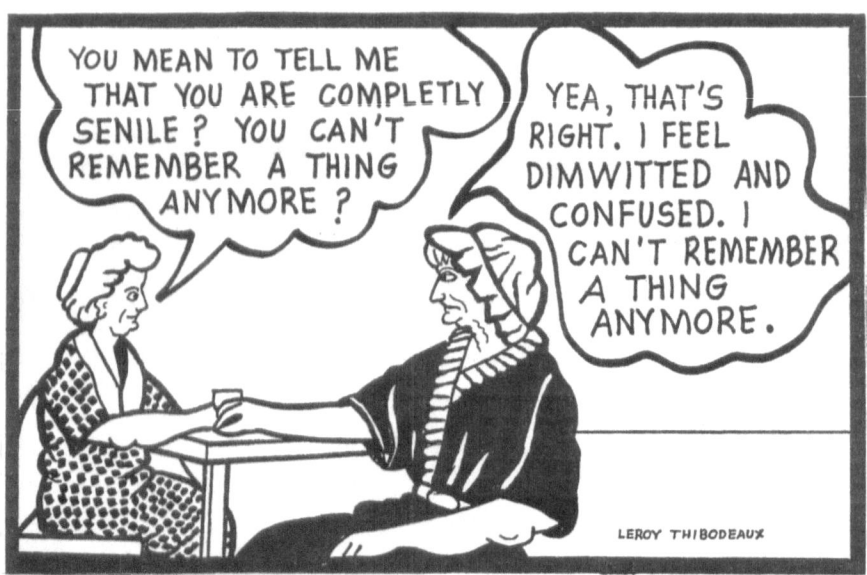
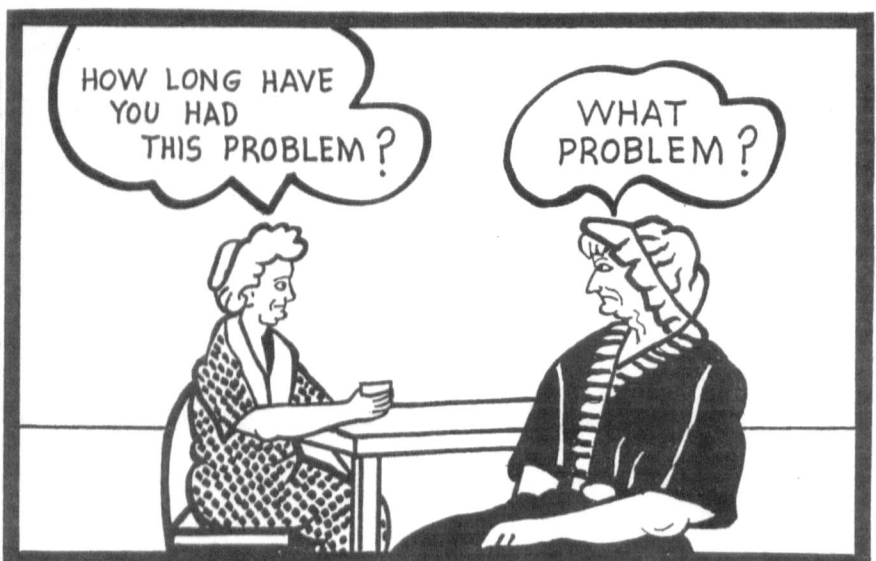

CAJUN COFFEE FOR SENIOR CITIZENS

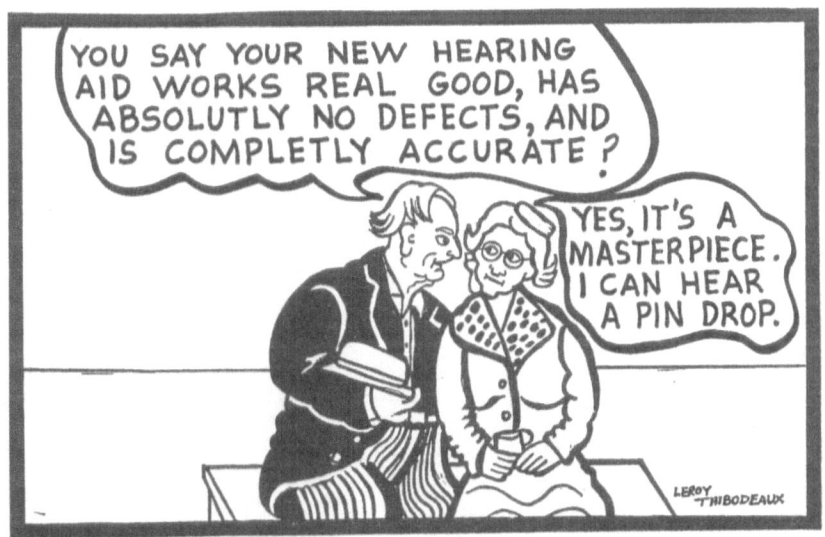

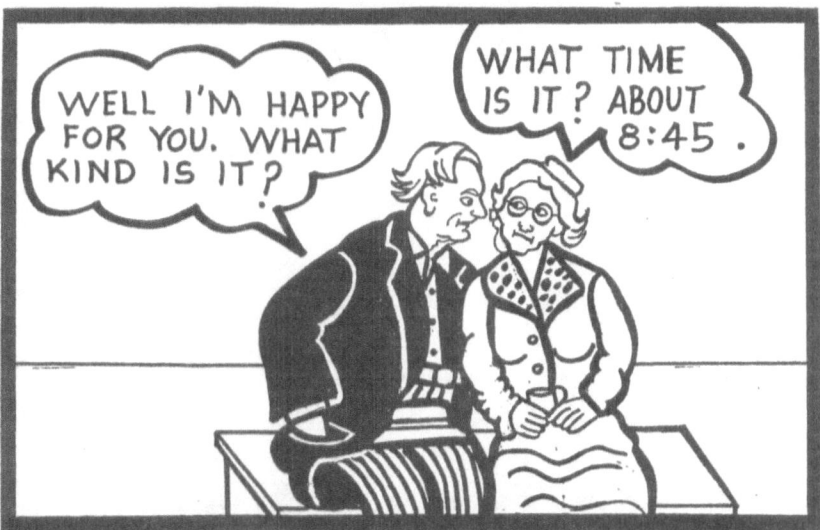

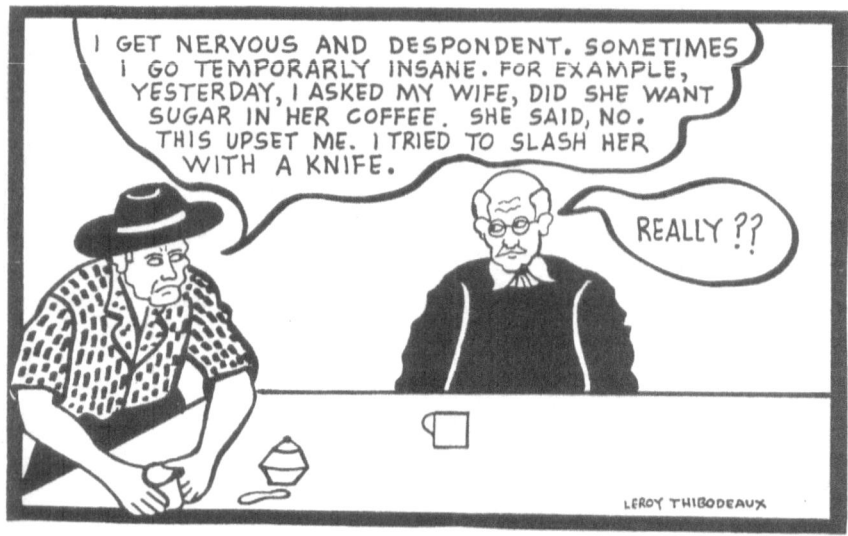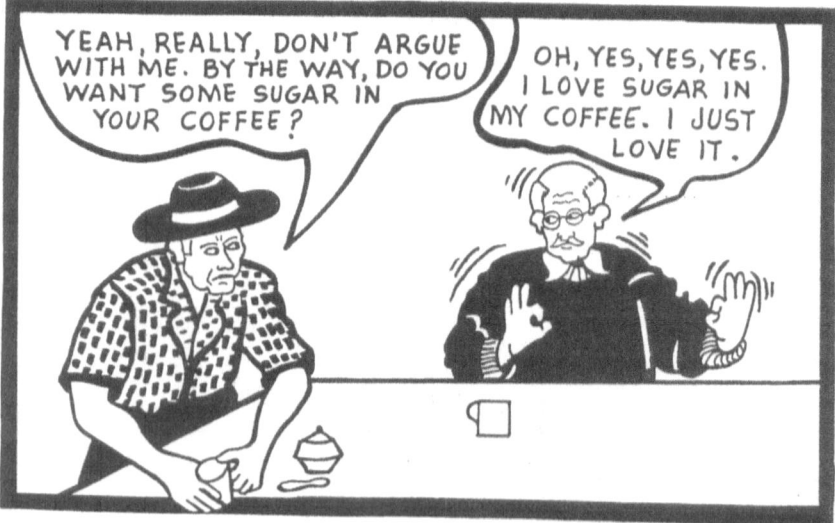

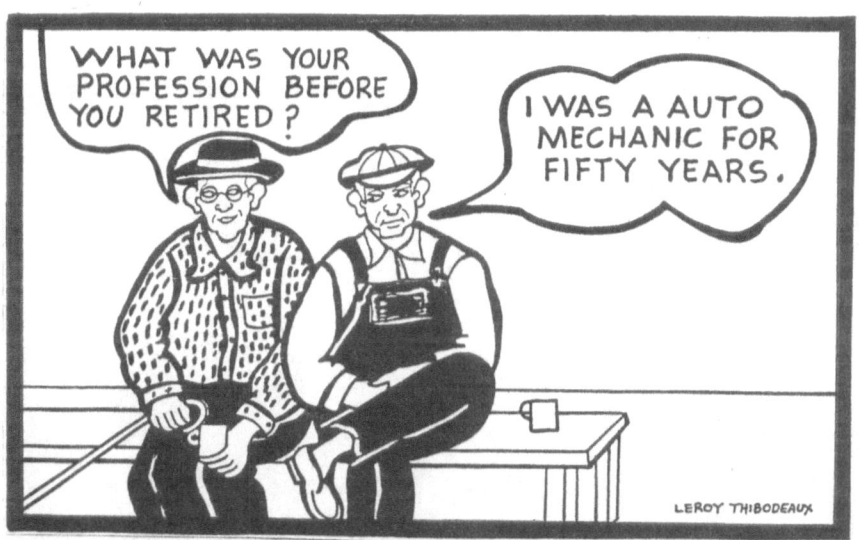
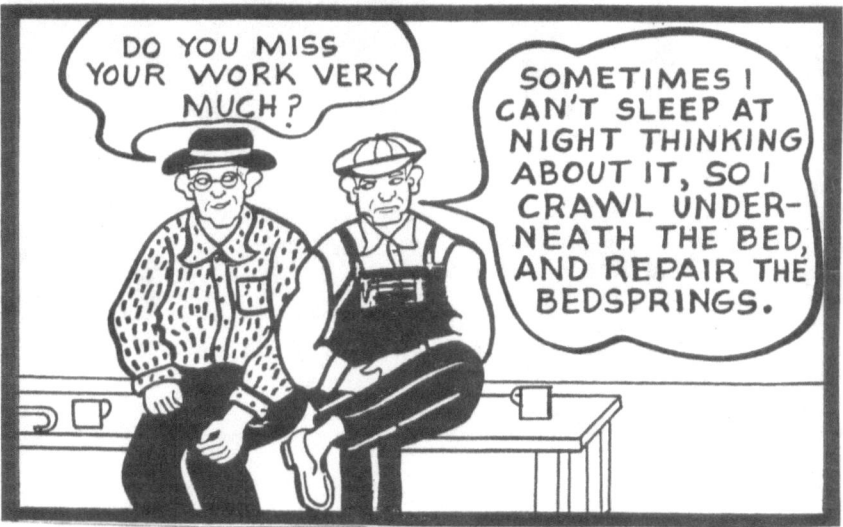

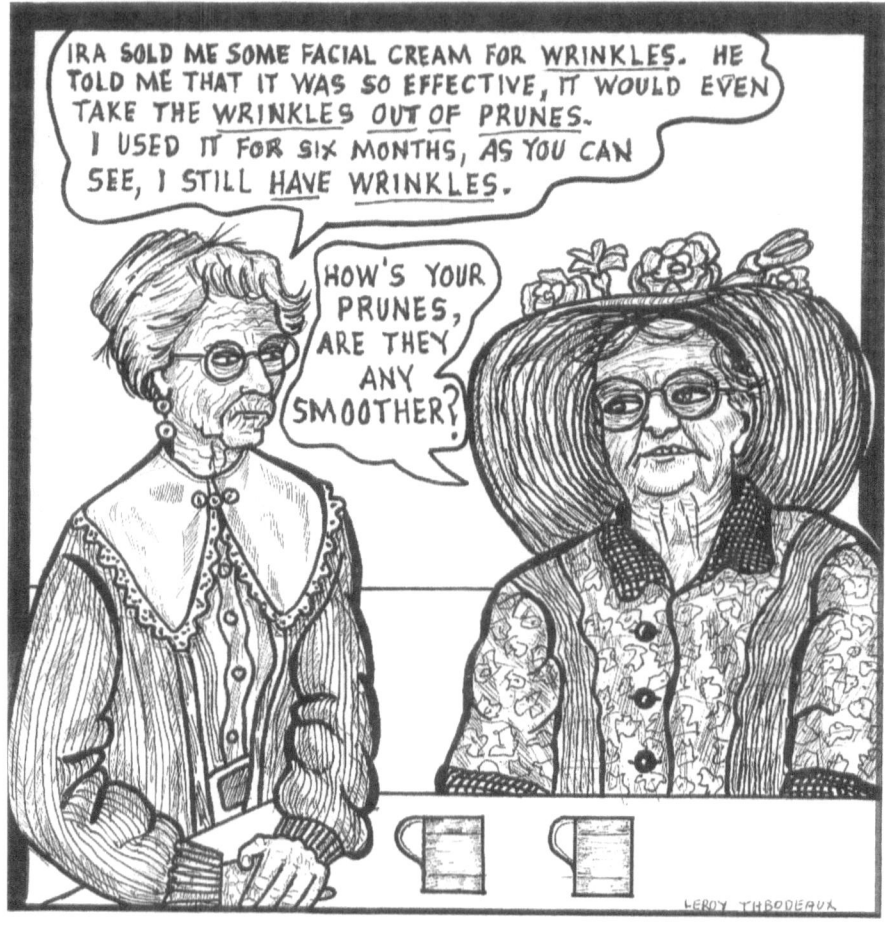

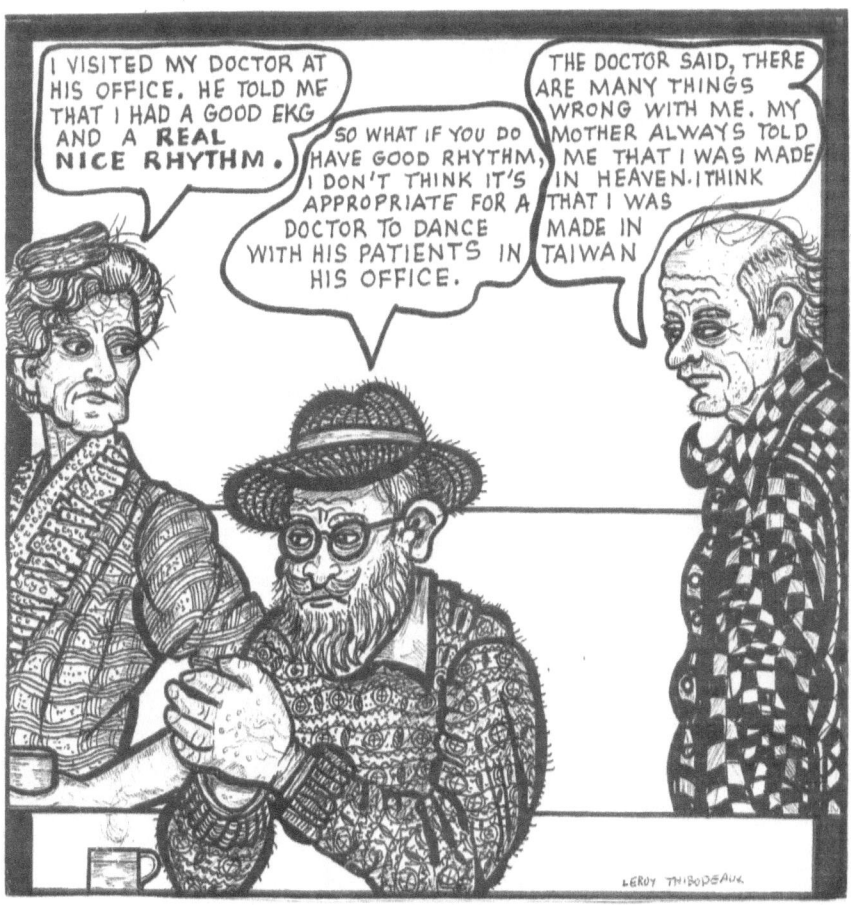

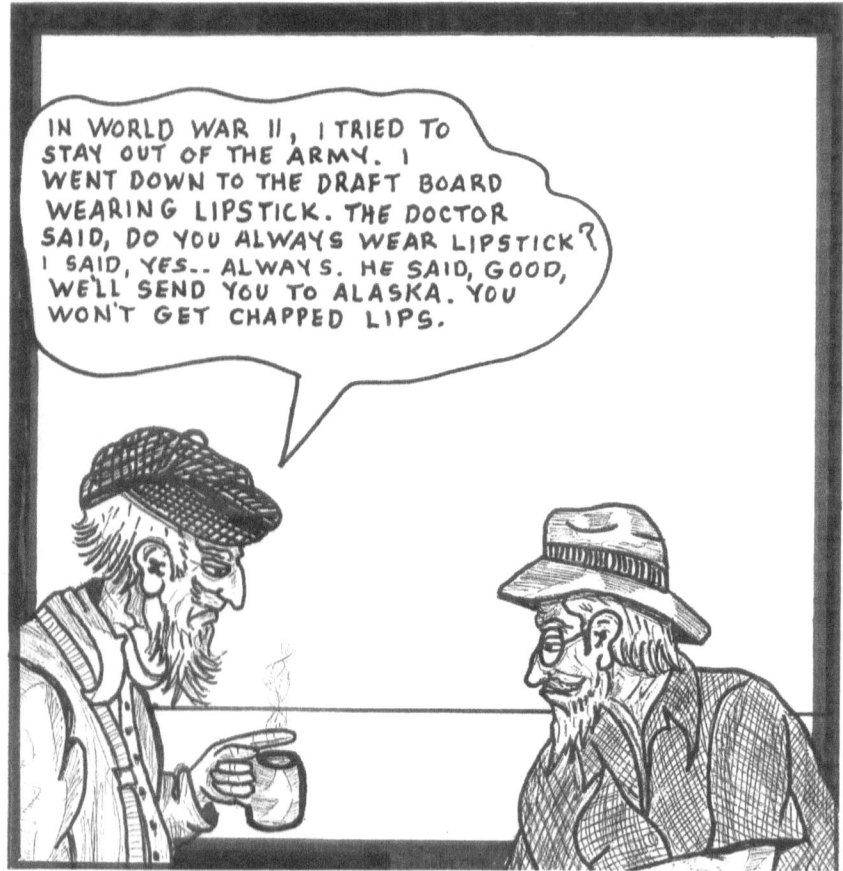

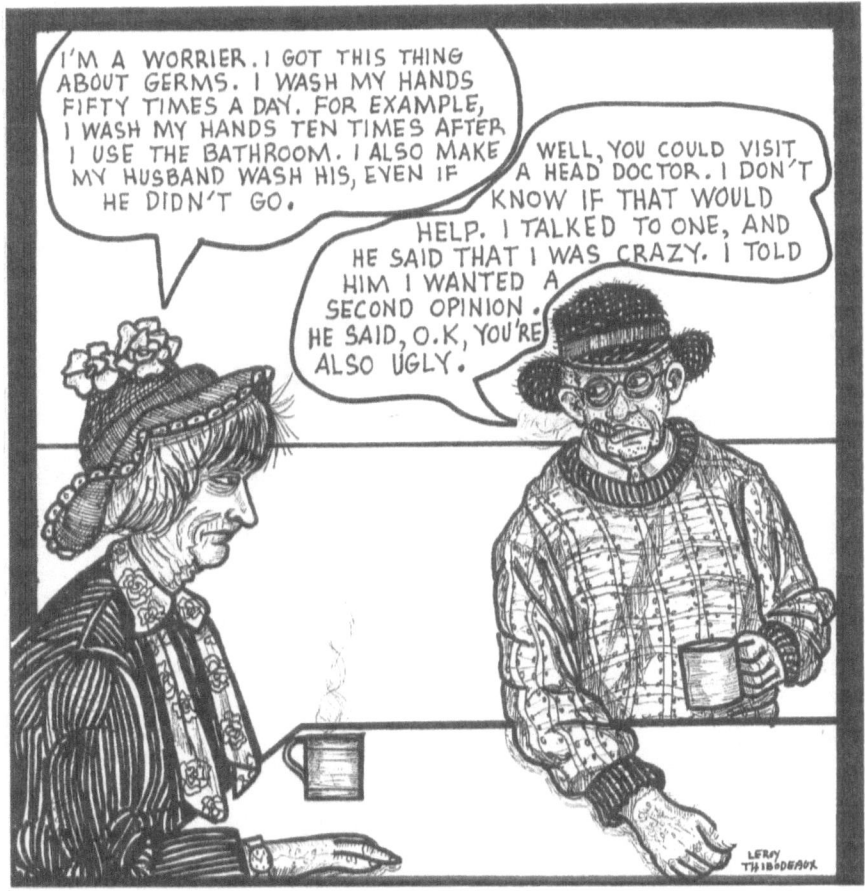

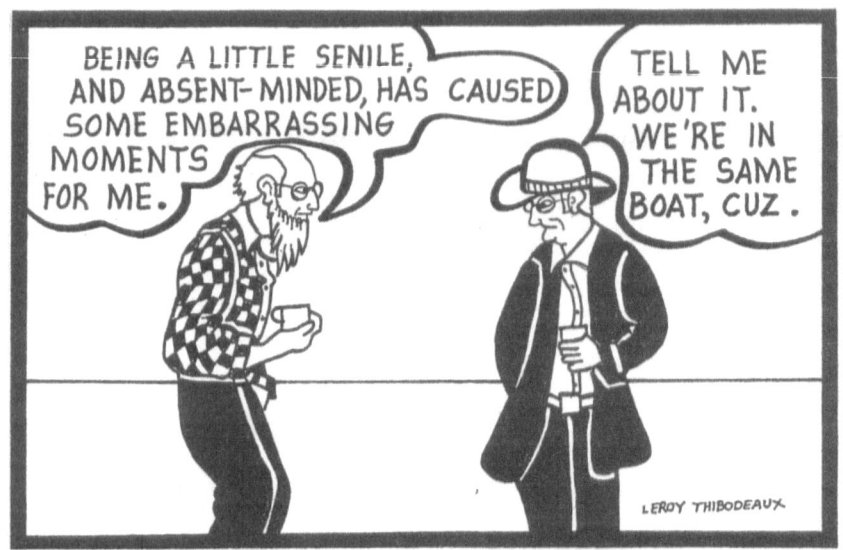
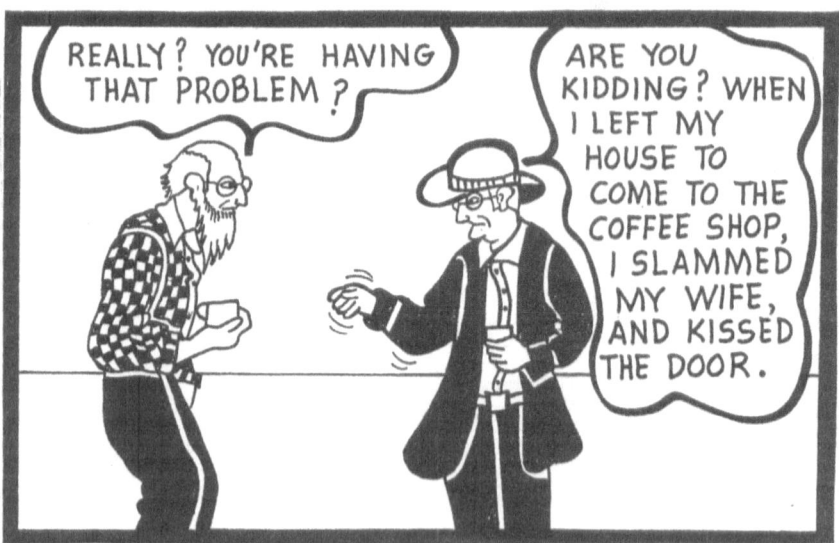

CAJUN COFFEE FOR SENIOR CITIZENS

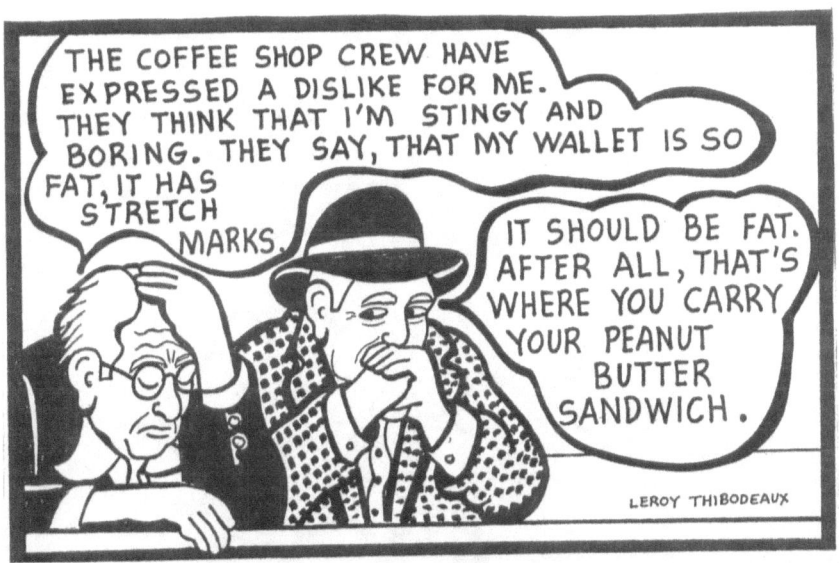

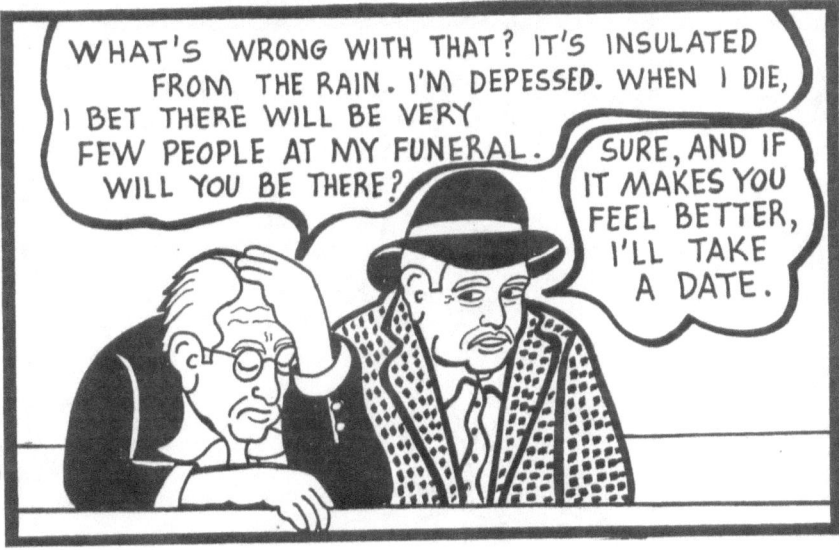

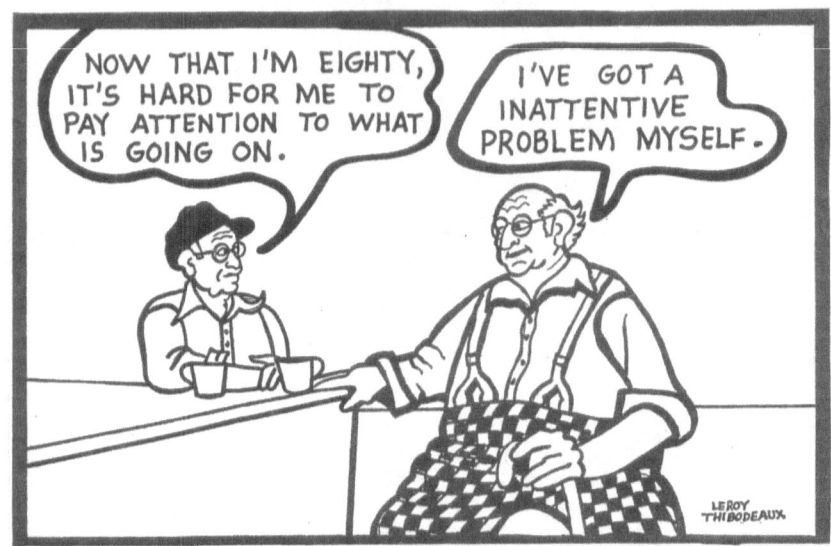
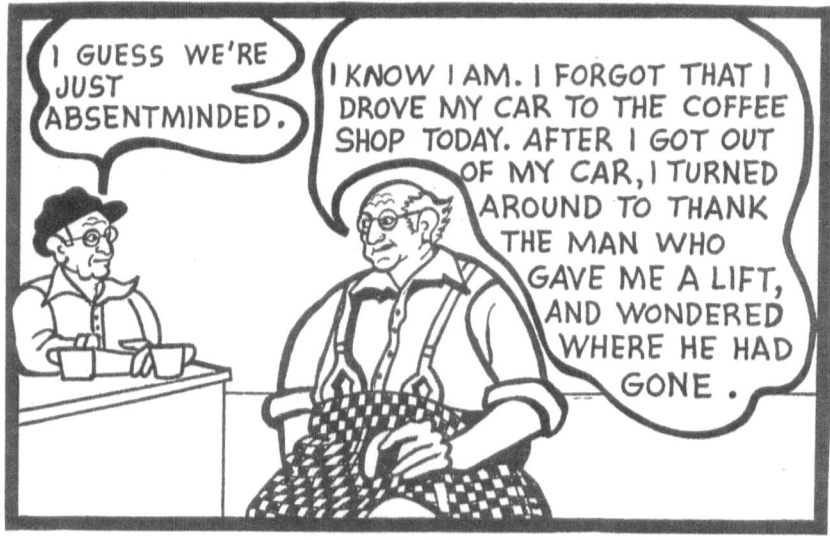

CAJUN COFFEE FOR SENIOR CITIZENS

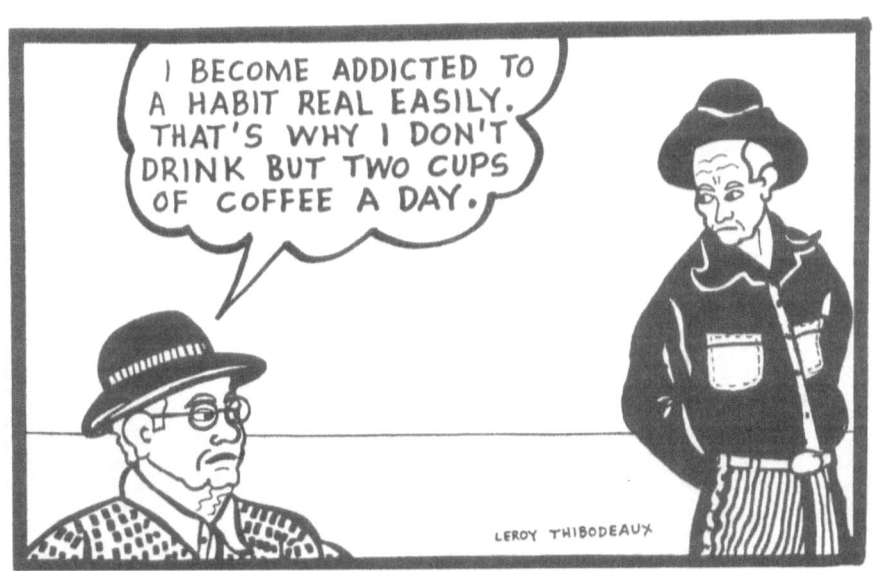

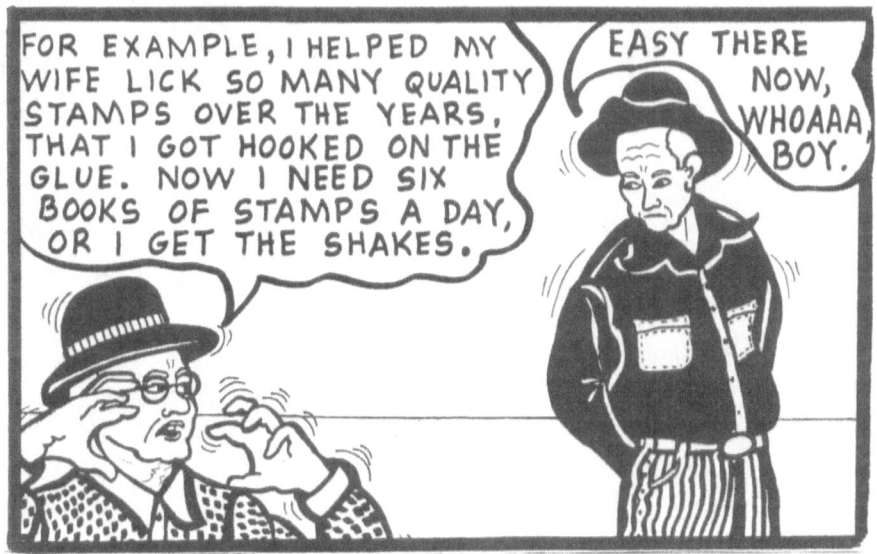

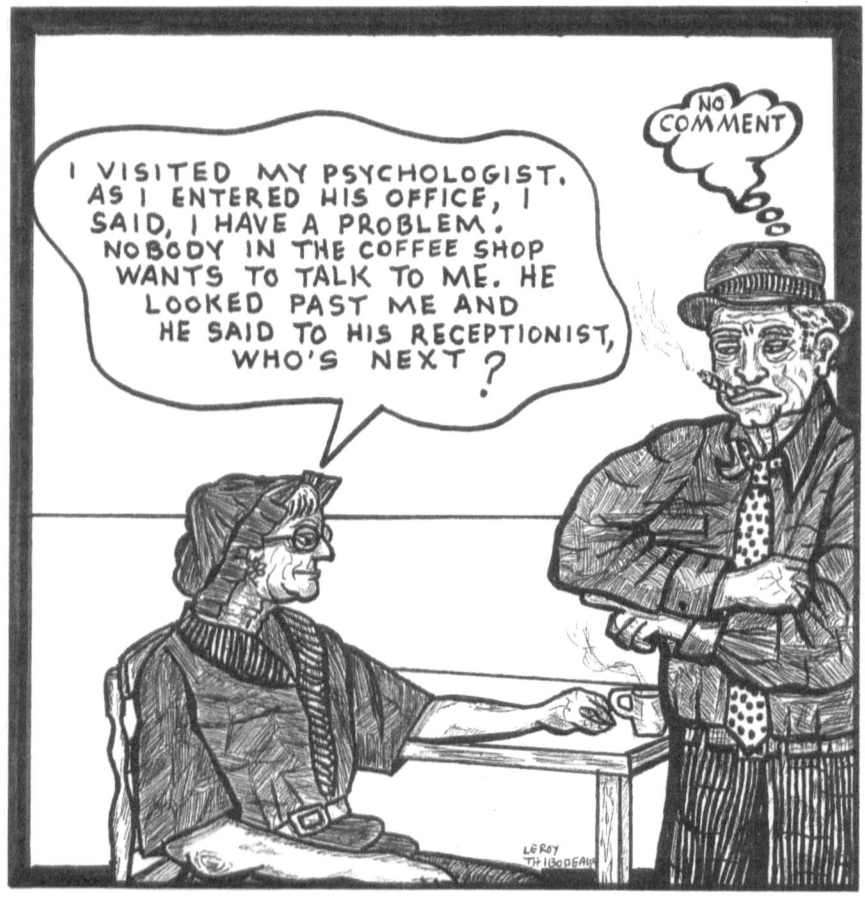

CAJUN COFFEE FOR SENIOR CITIZENS

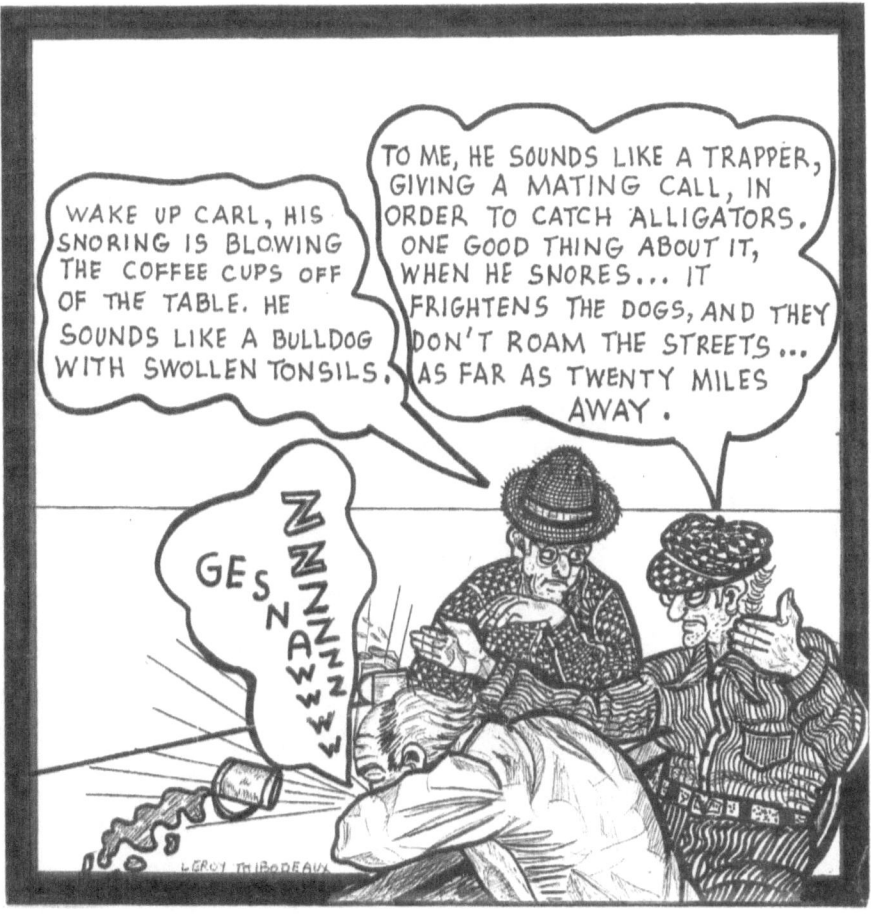

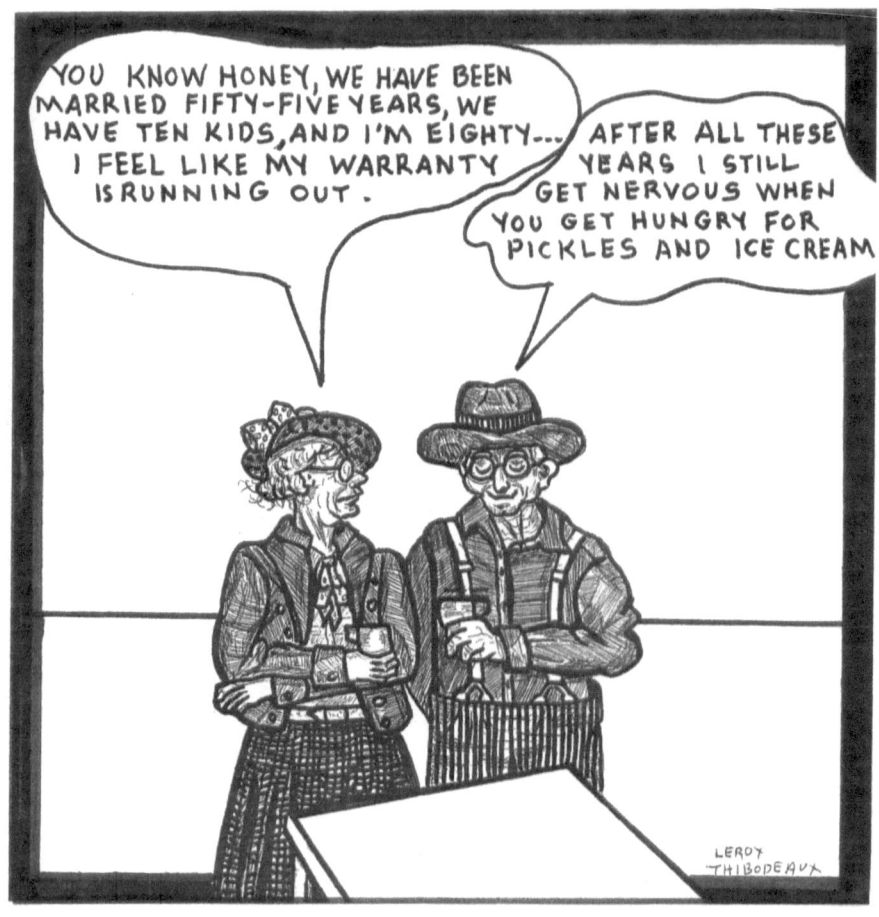

CAJUN COFFEE FOR SENIOR CITIZENS

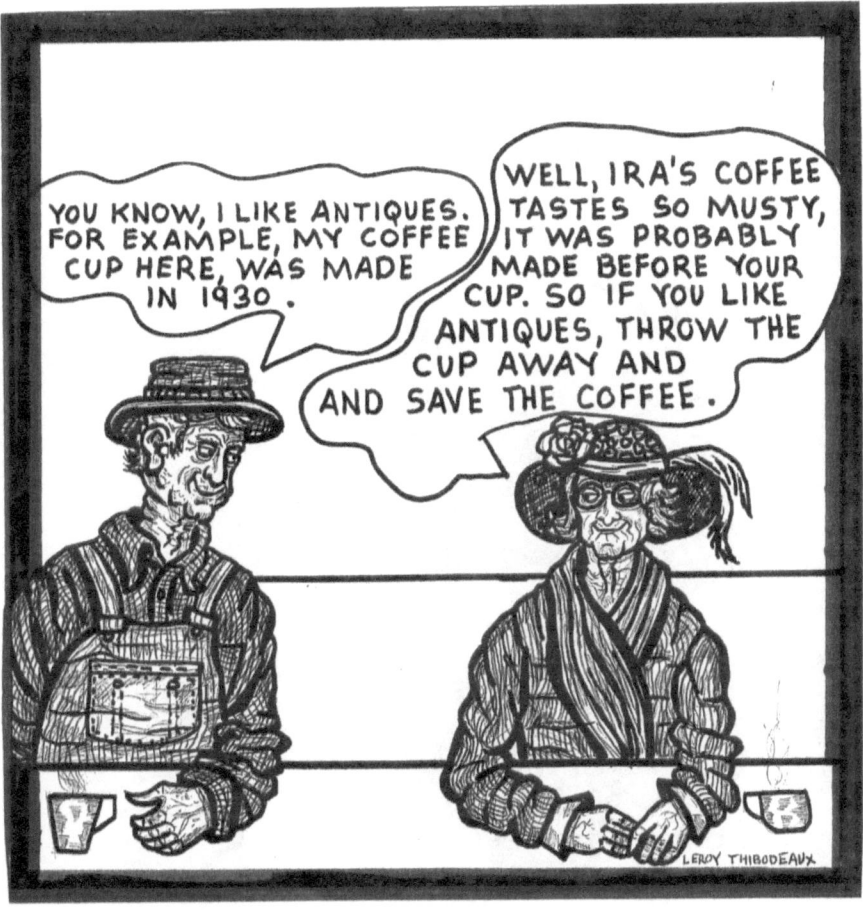

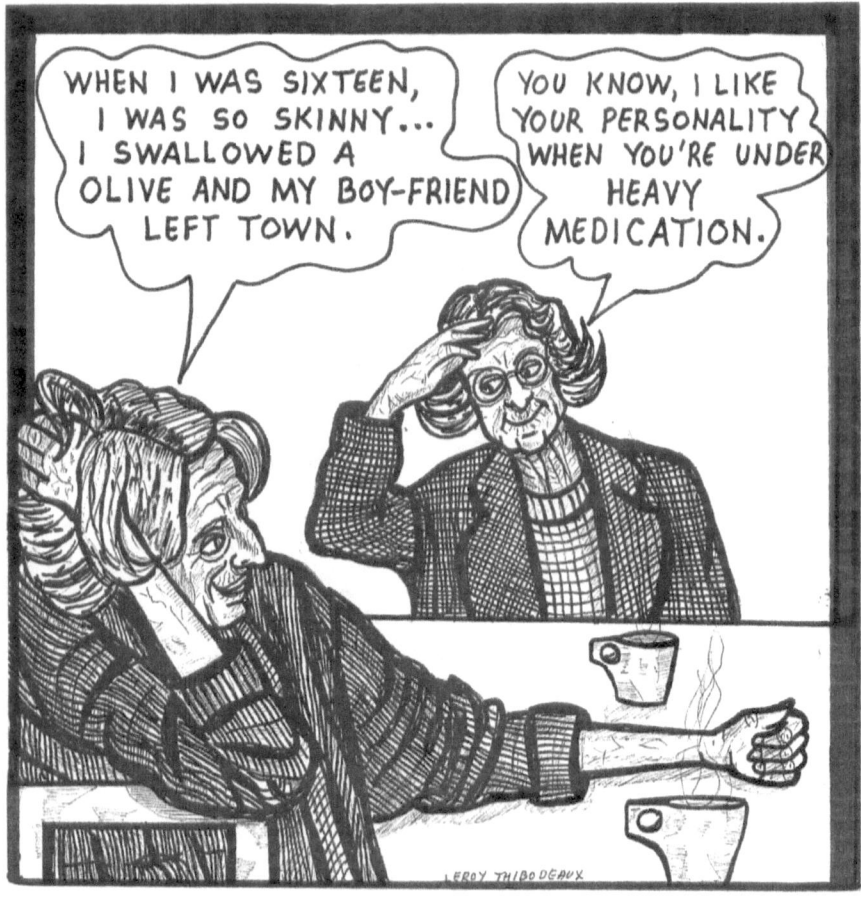

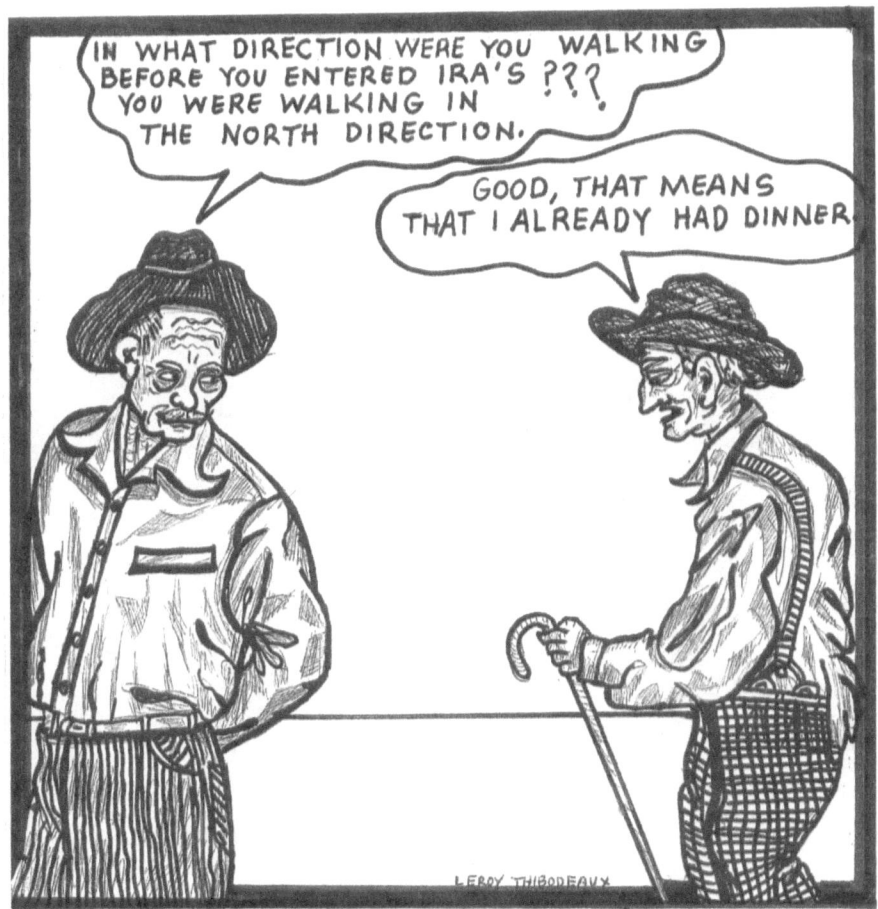

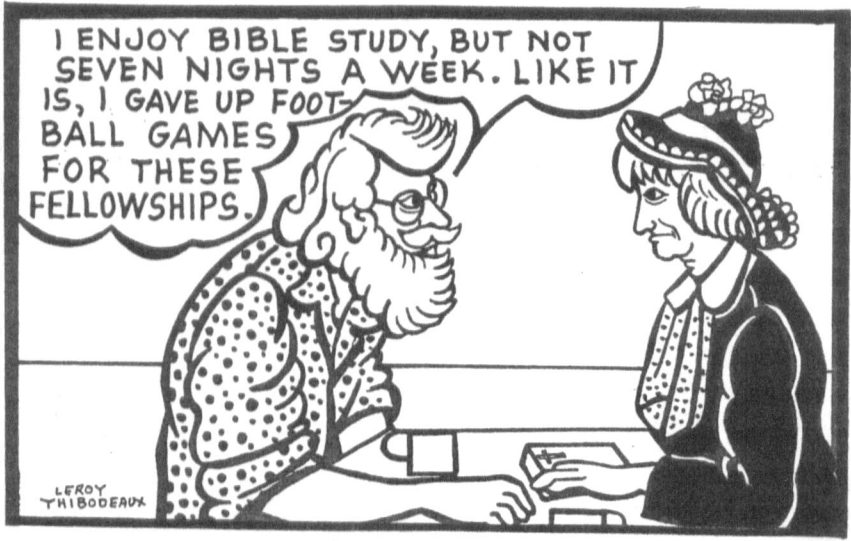
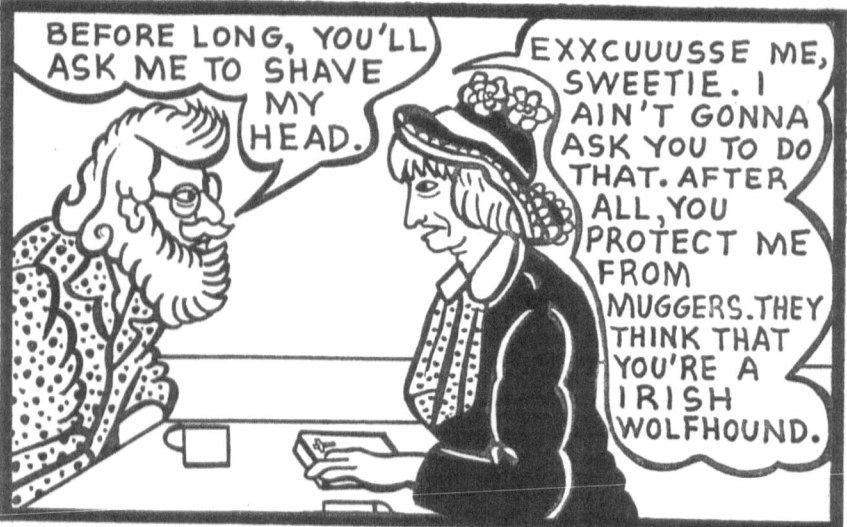

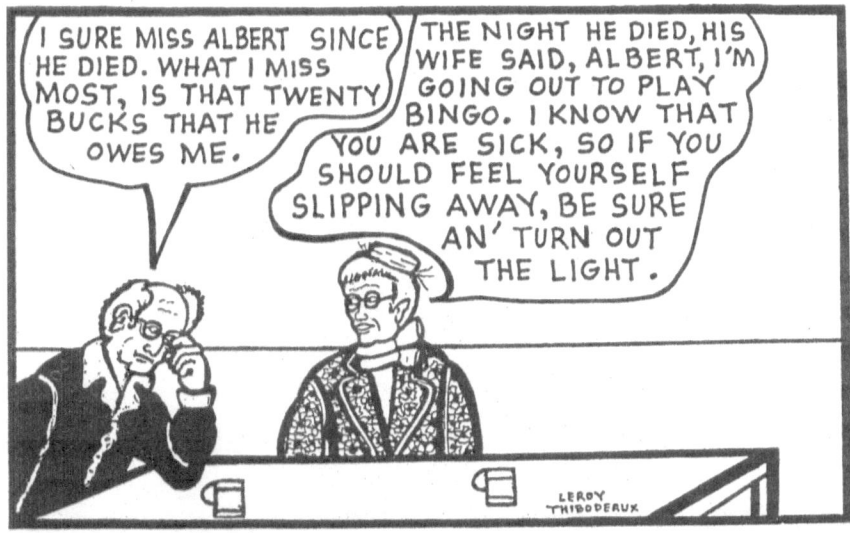
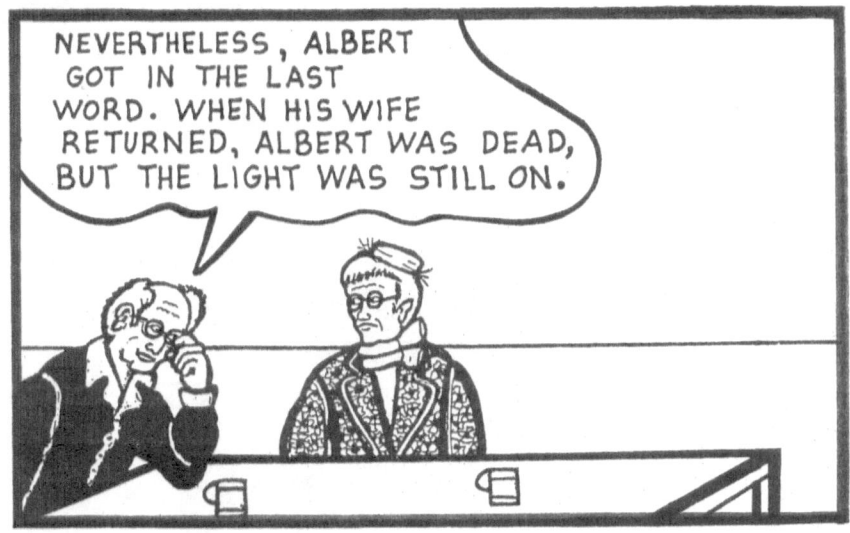

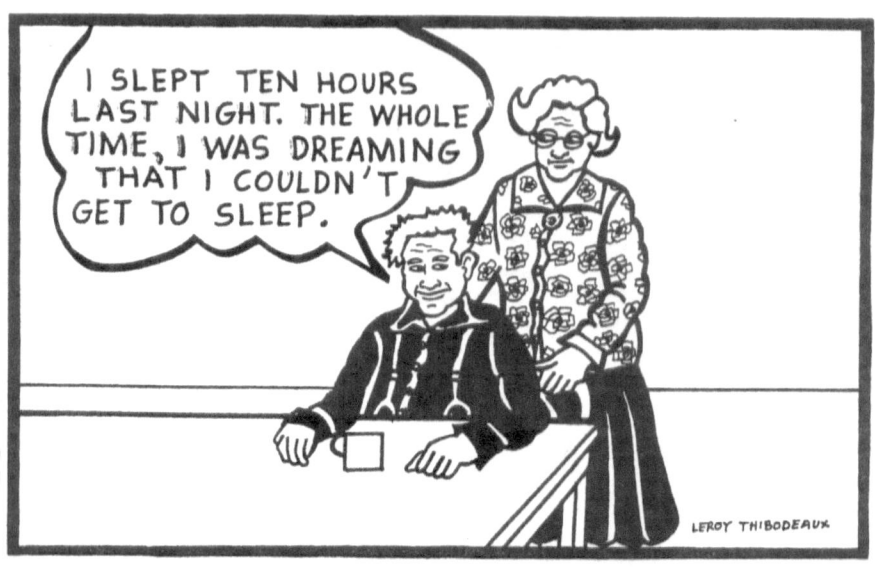
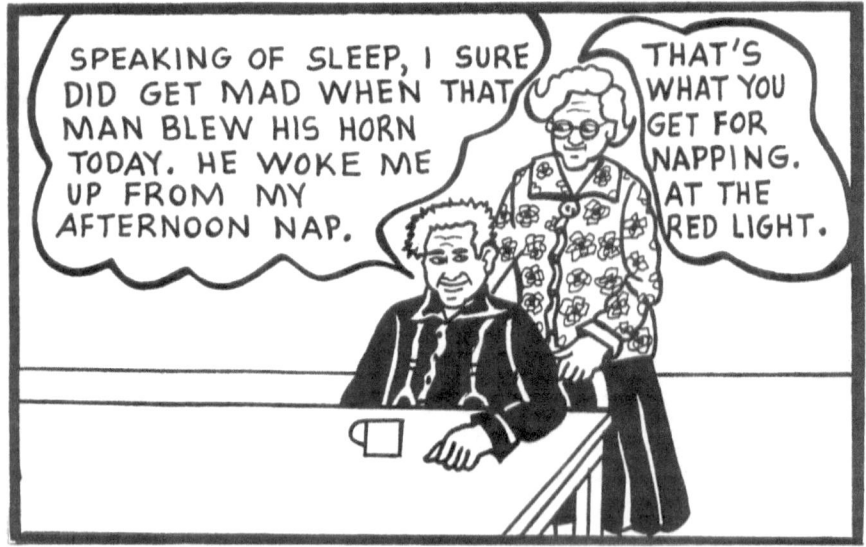

CAJUN COFFEE FOR SENIOR CITIZENS

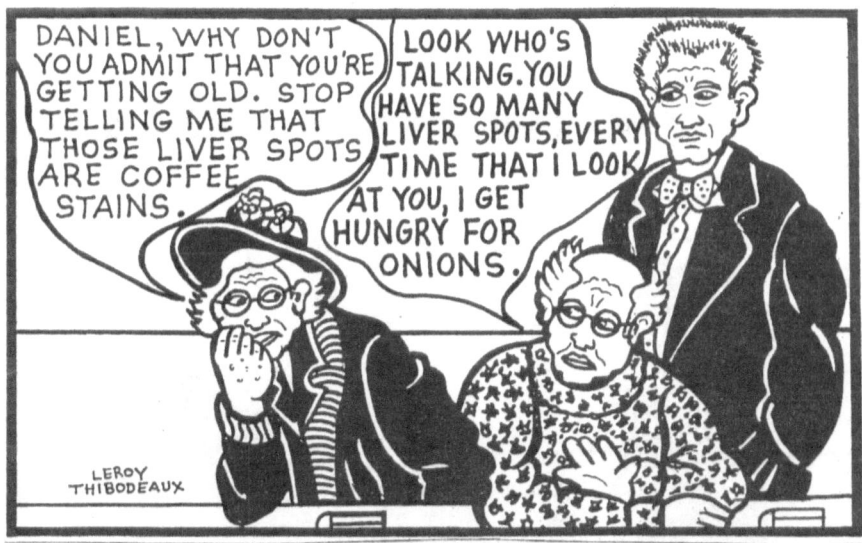

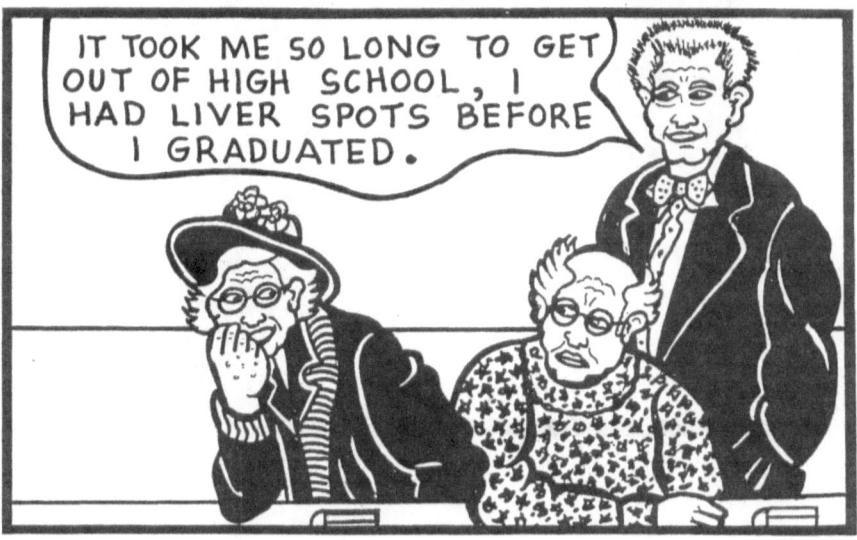

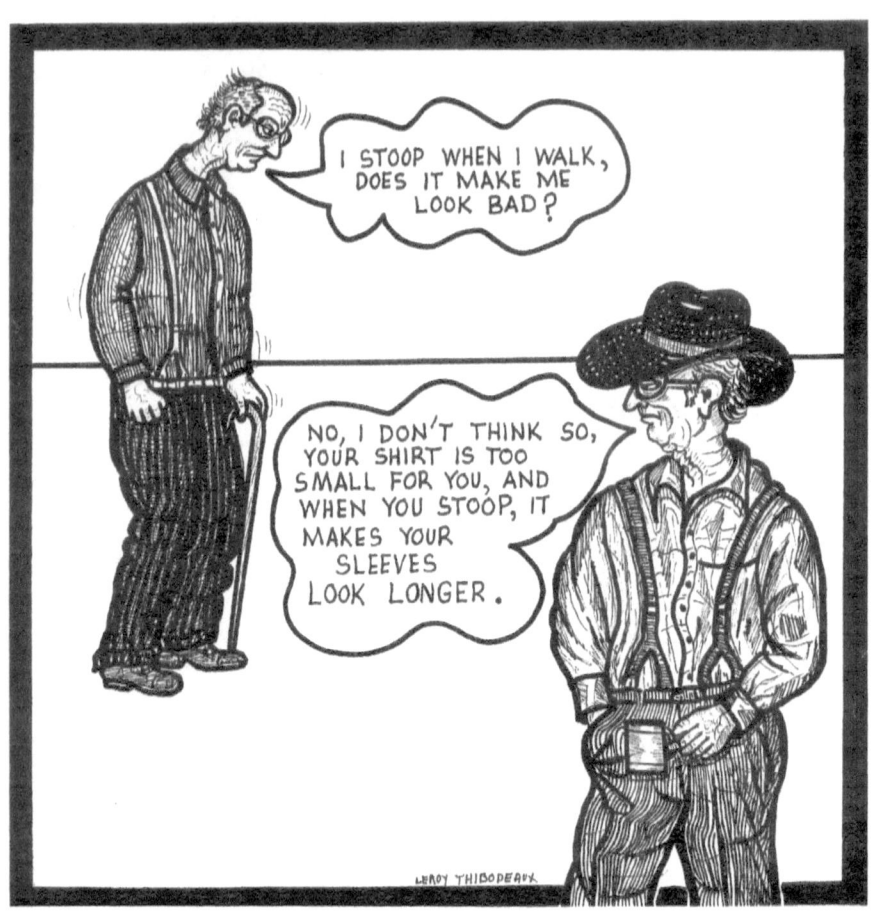

CAJUN COFFEE FOR SENIOR CITIZENS

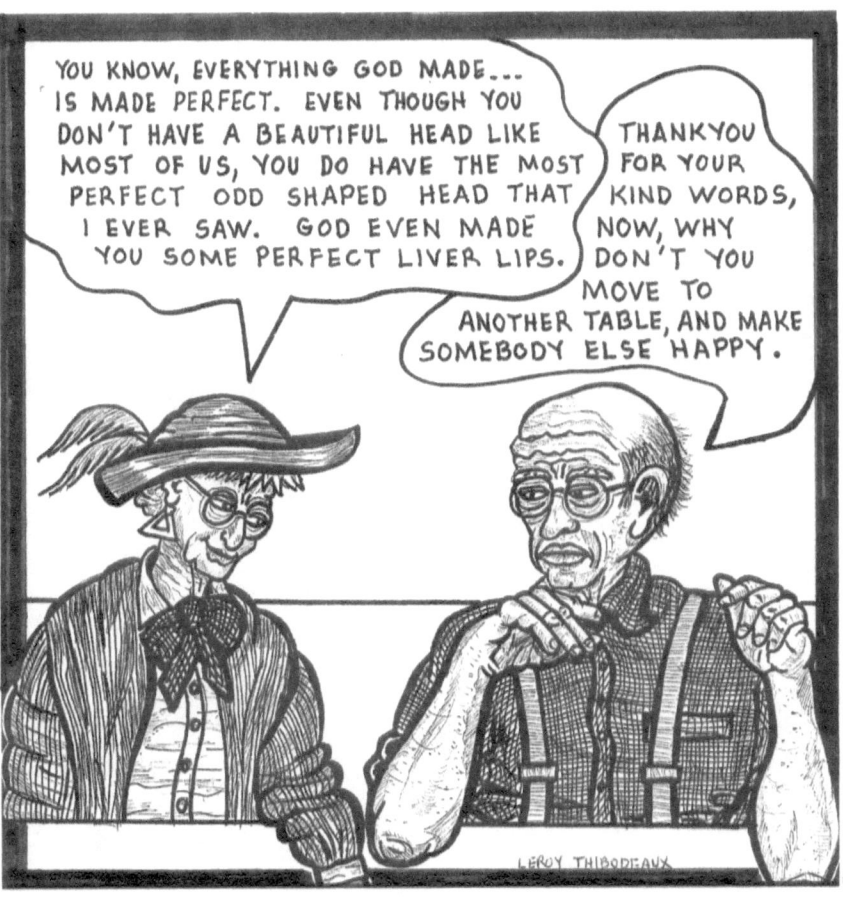

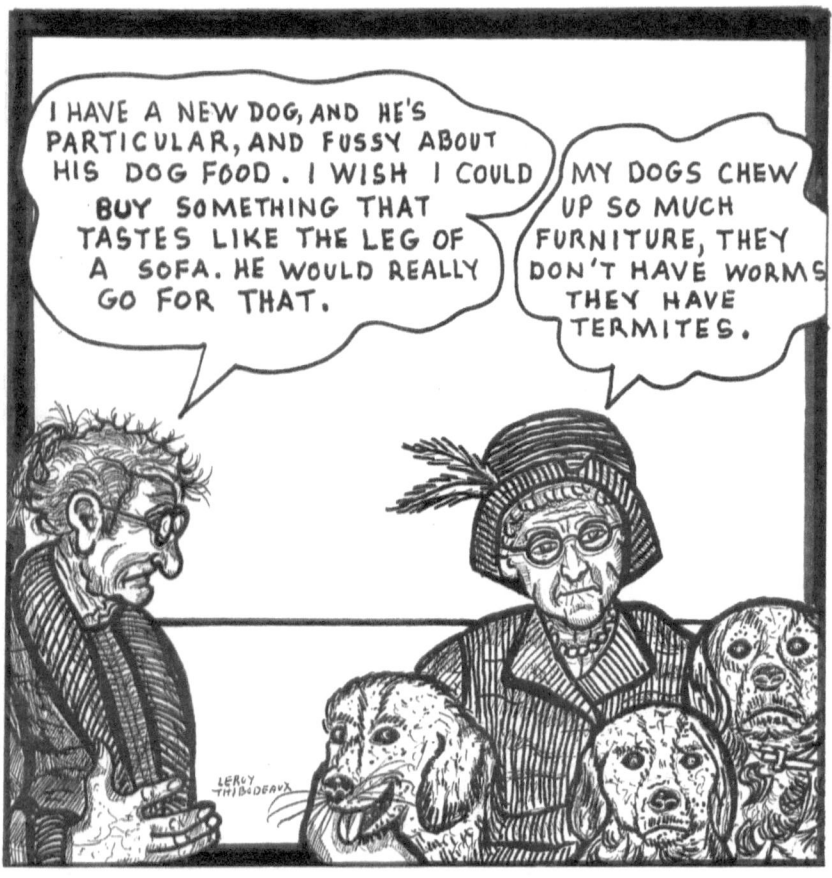

CAJUN COFFEE FOR SENIOR CITIZENS

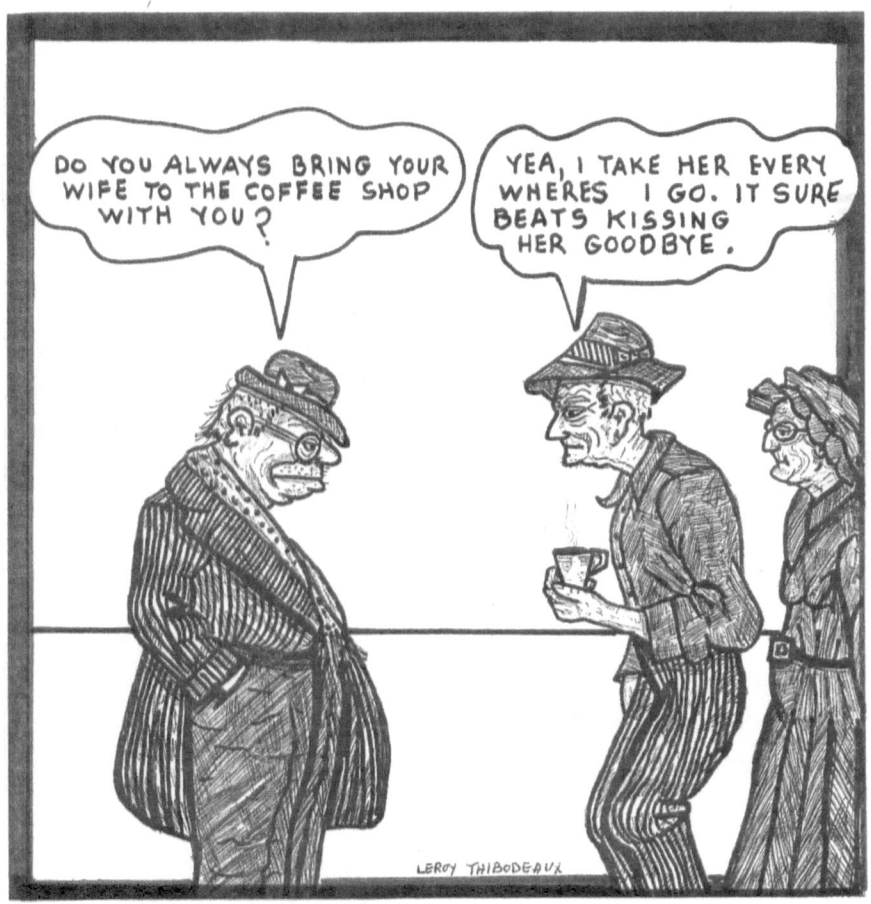

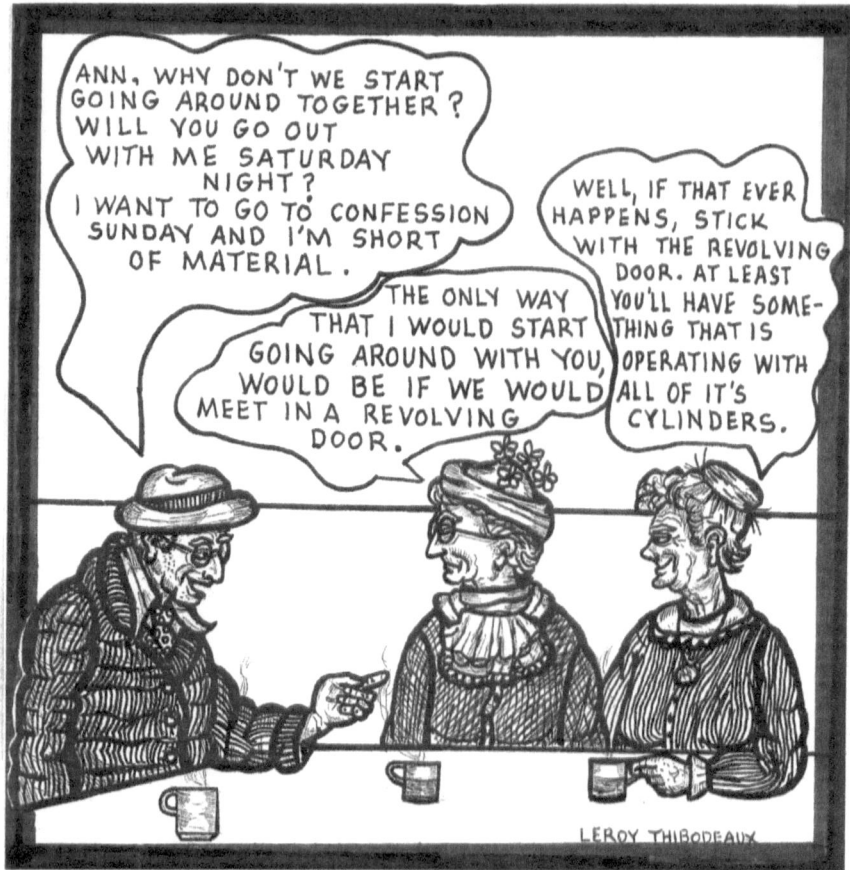

CAJUN COFFEE FOR SENIOR CITIZENS 43

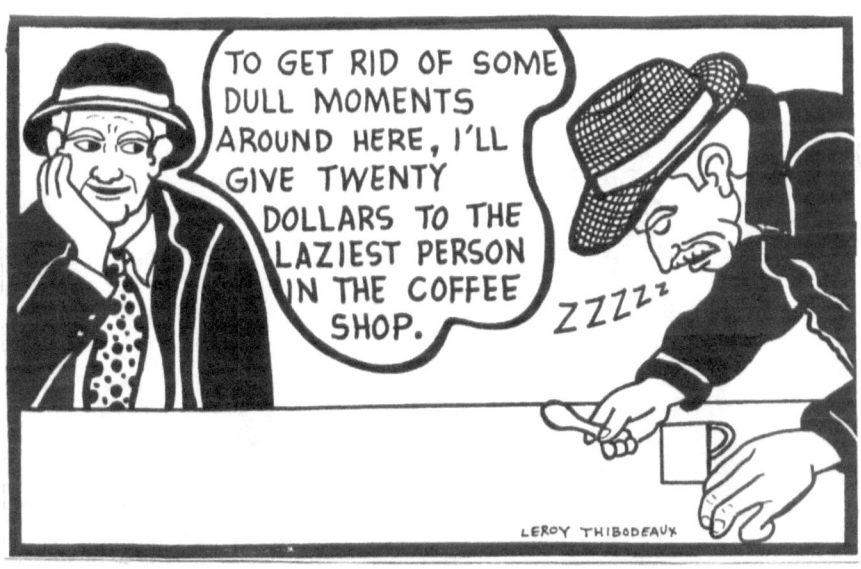
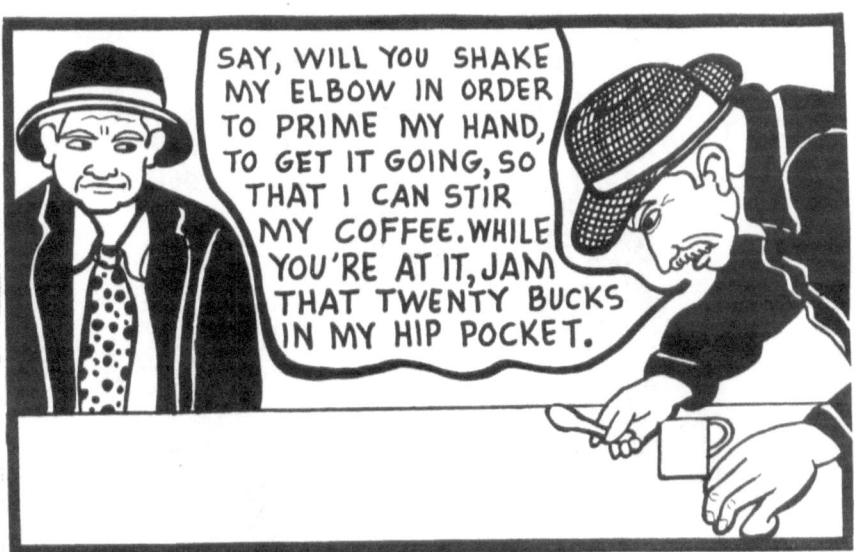

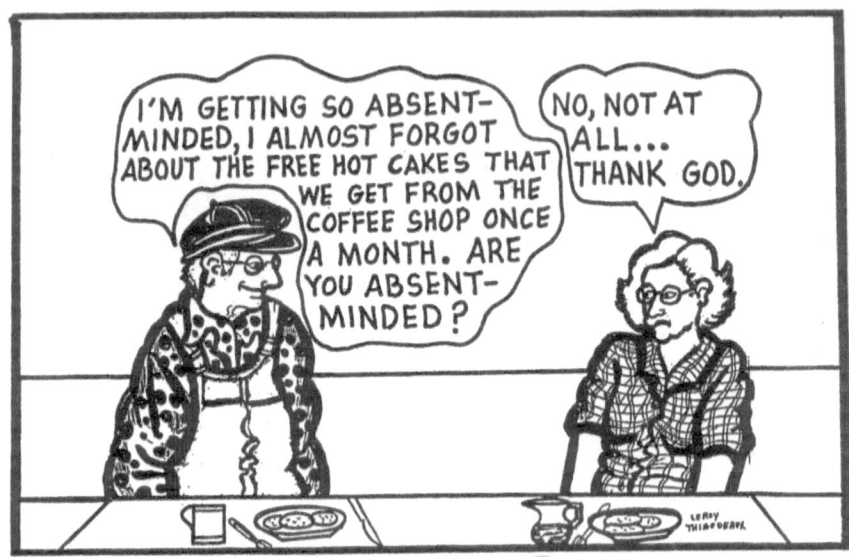
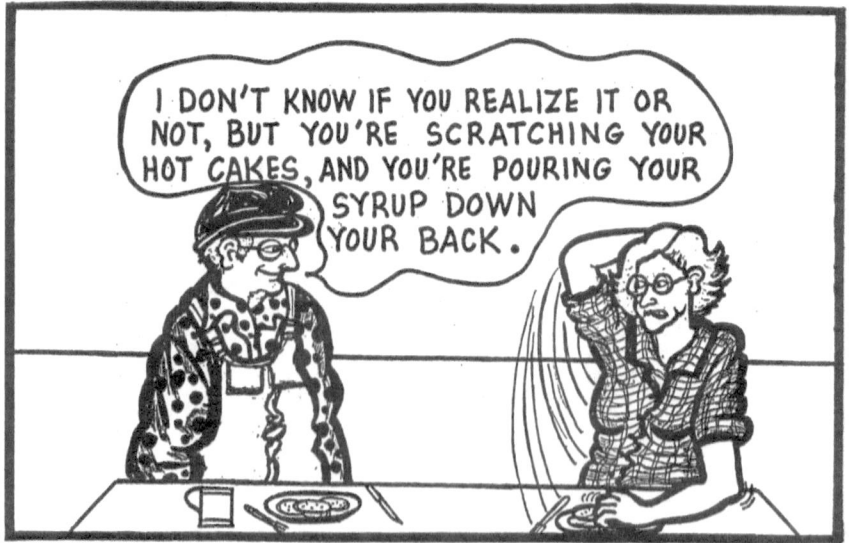

CAJUN COFFEE FOR SENIOR CITIZENS

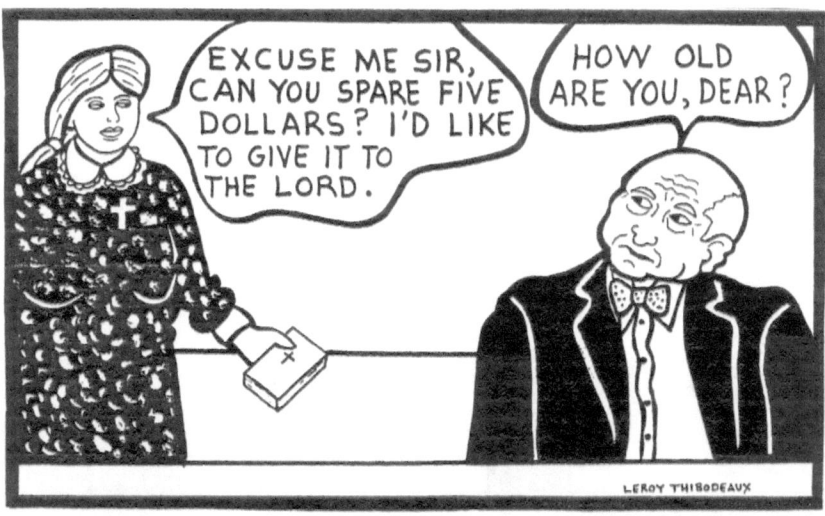

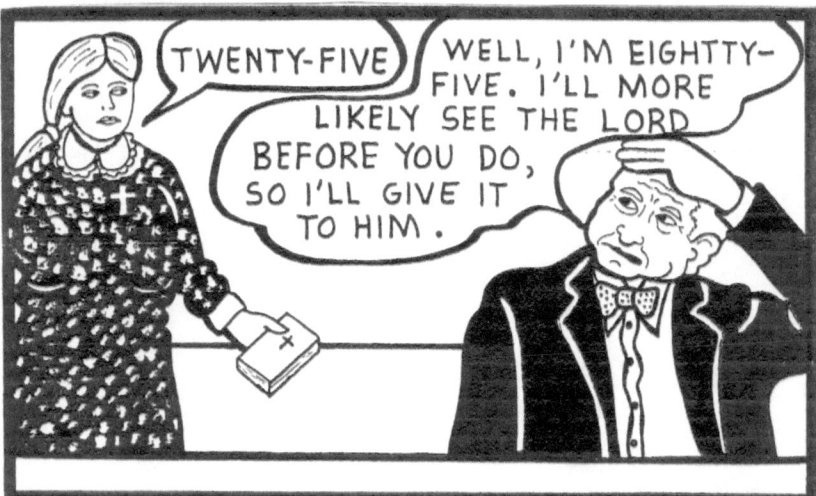

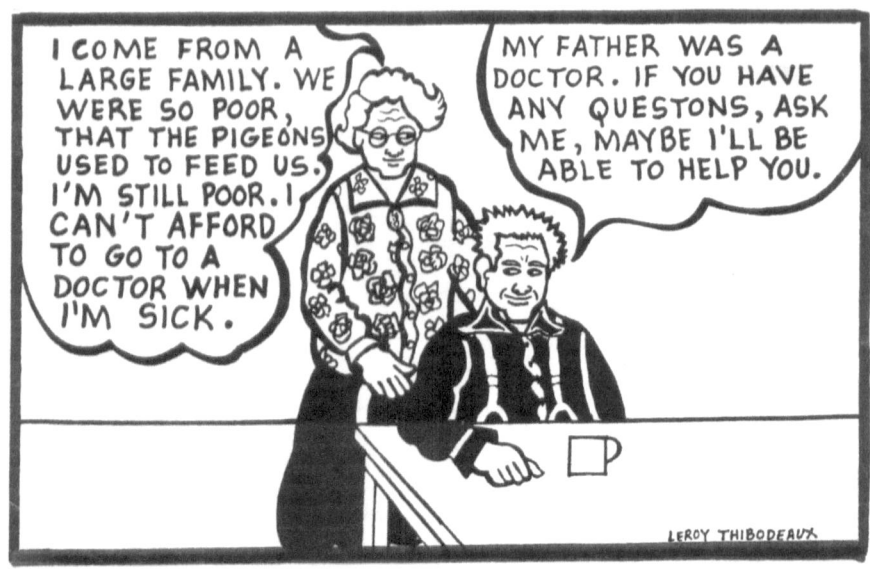
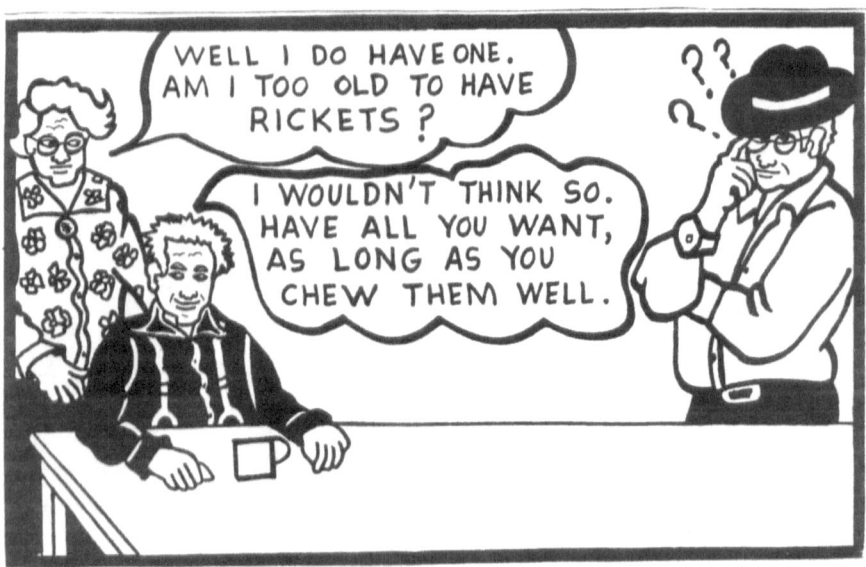

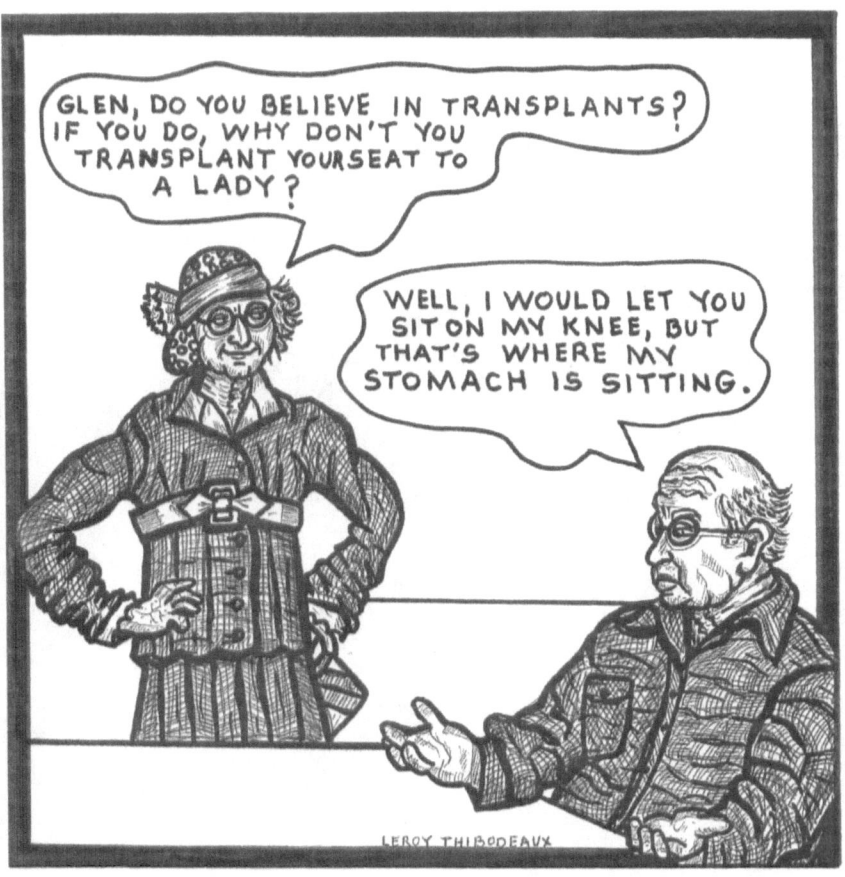

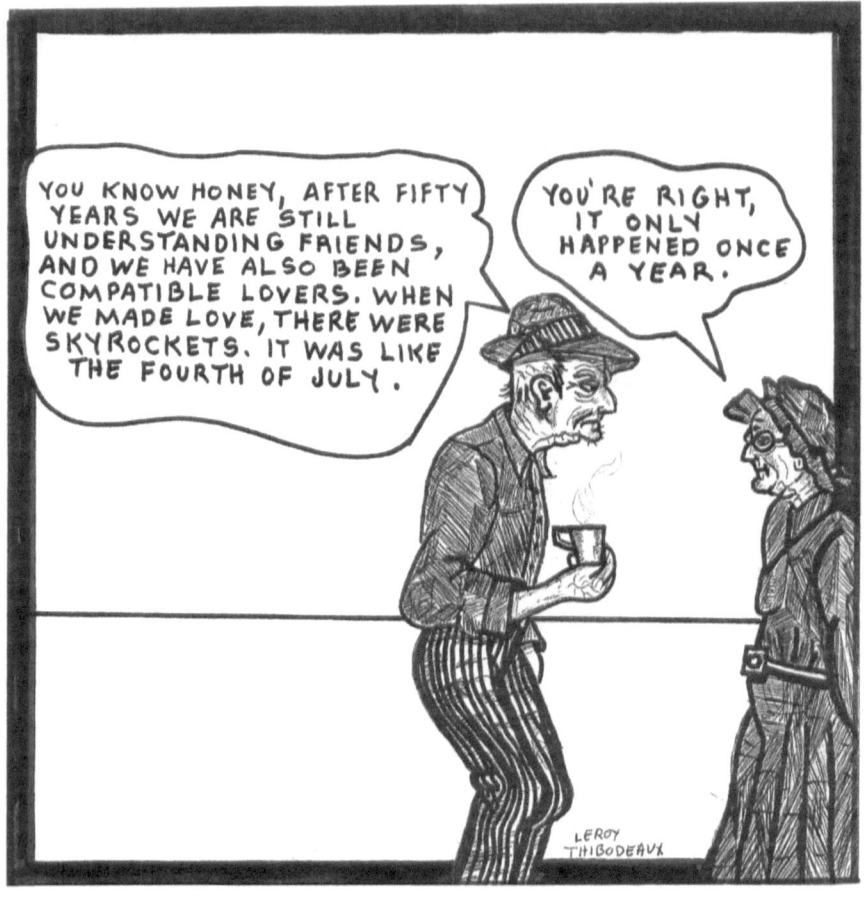

CAJUN COFFEE FOR SENIOR CITIZENS

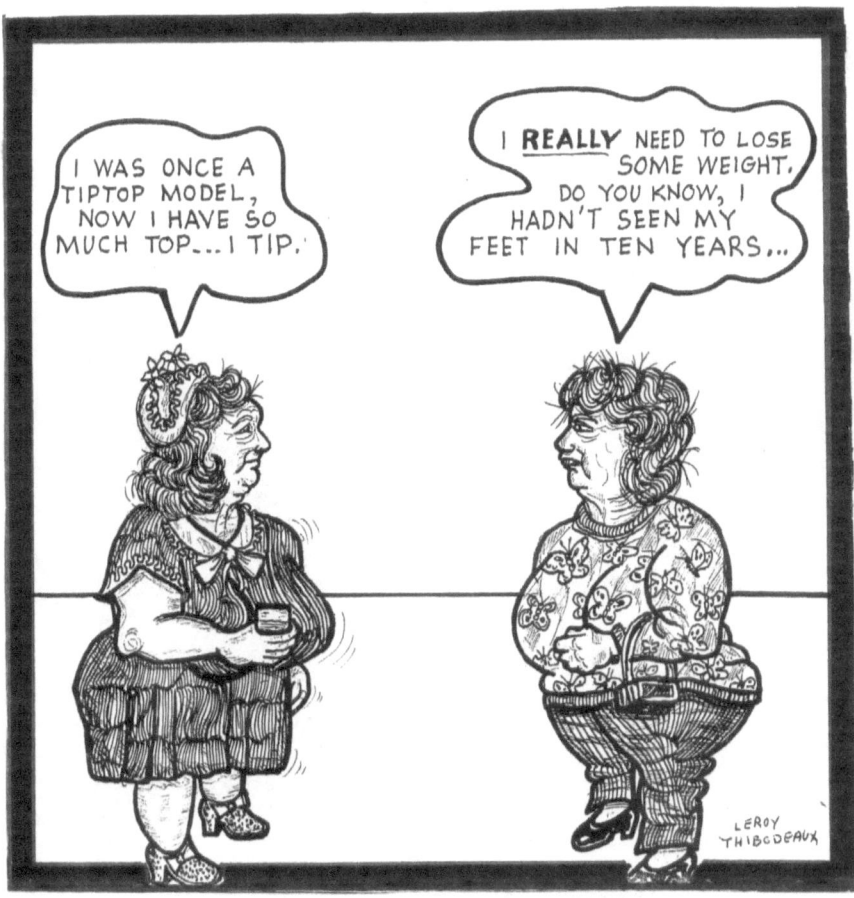

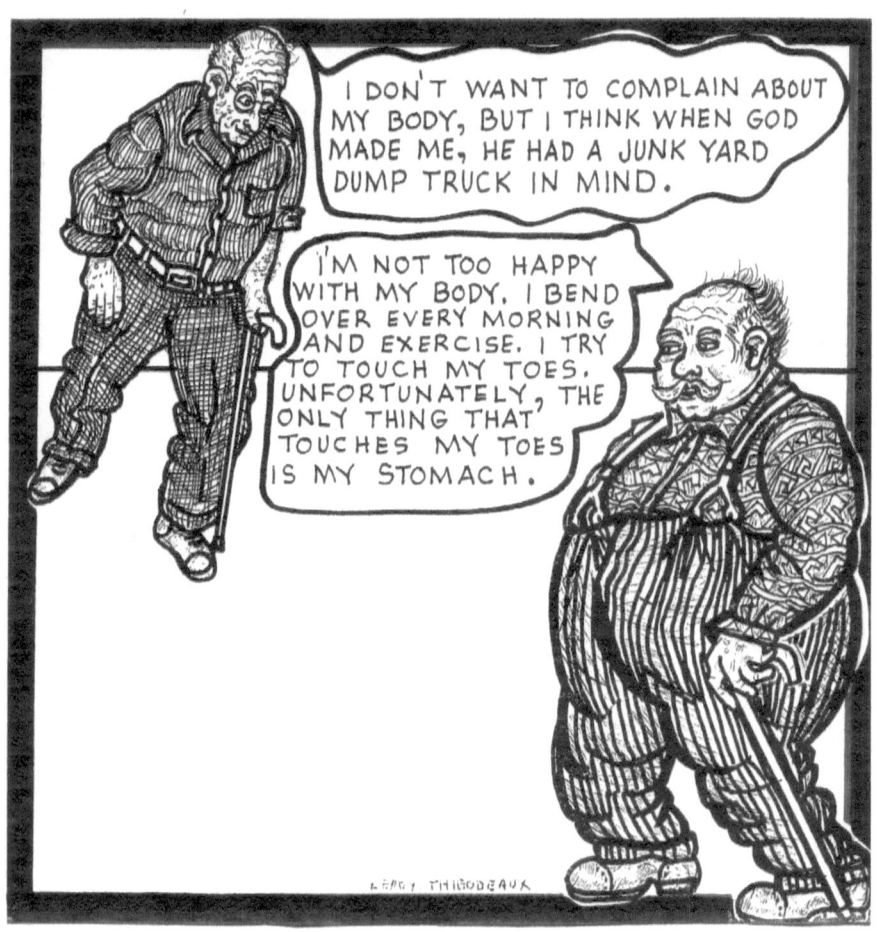

CAJUN COFFEE FOR SENIOR CITIZENS

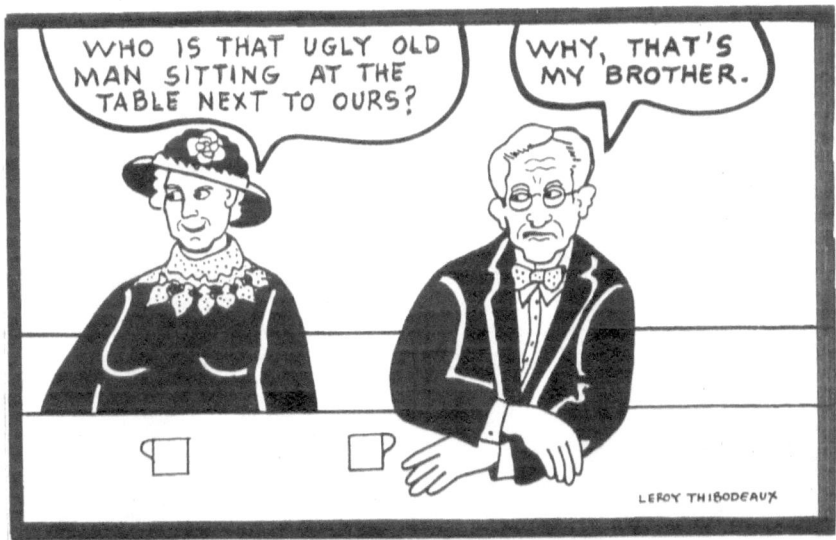

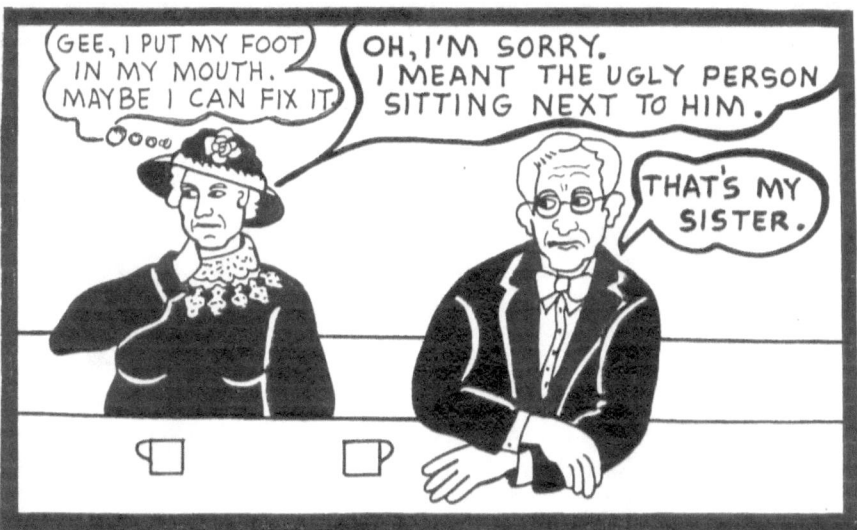

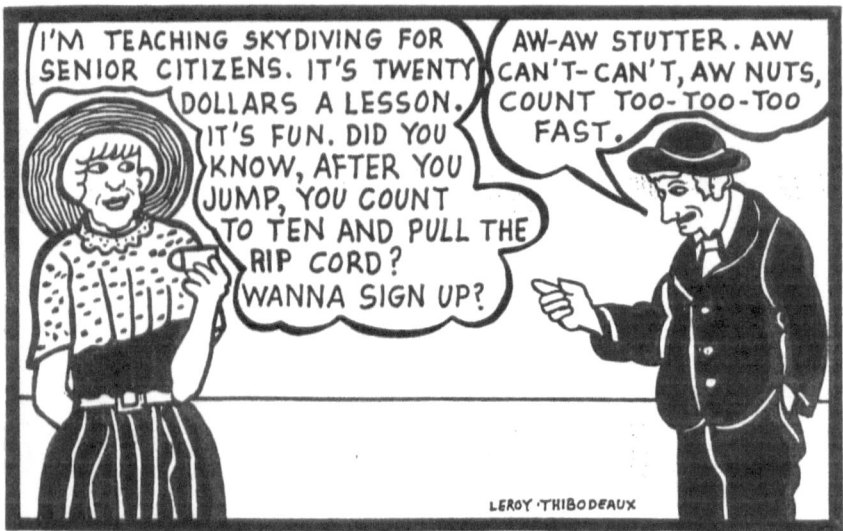
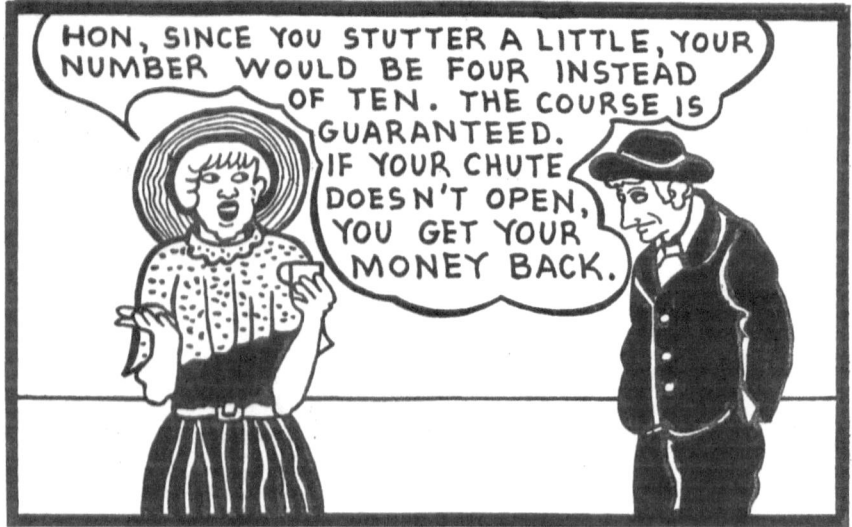

CAJUN COFFEE FOR SENIOR CITIZENS

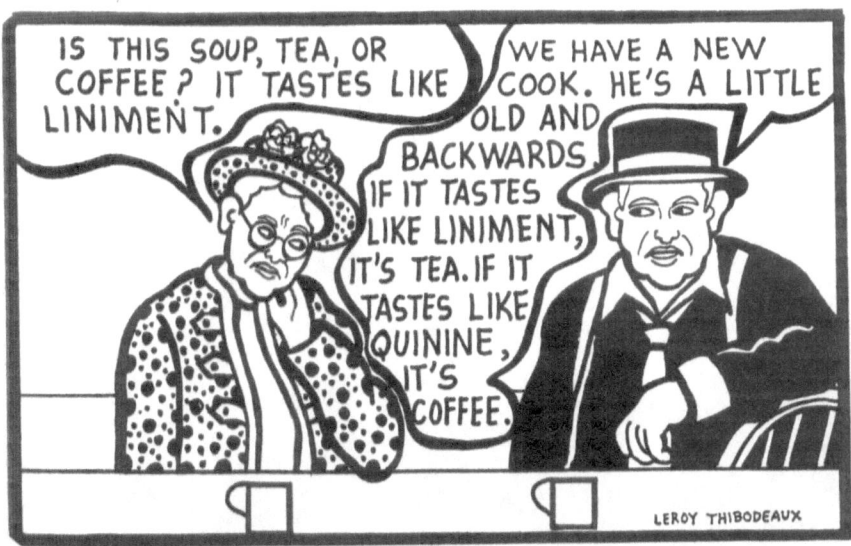

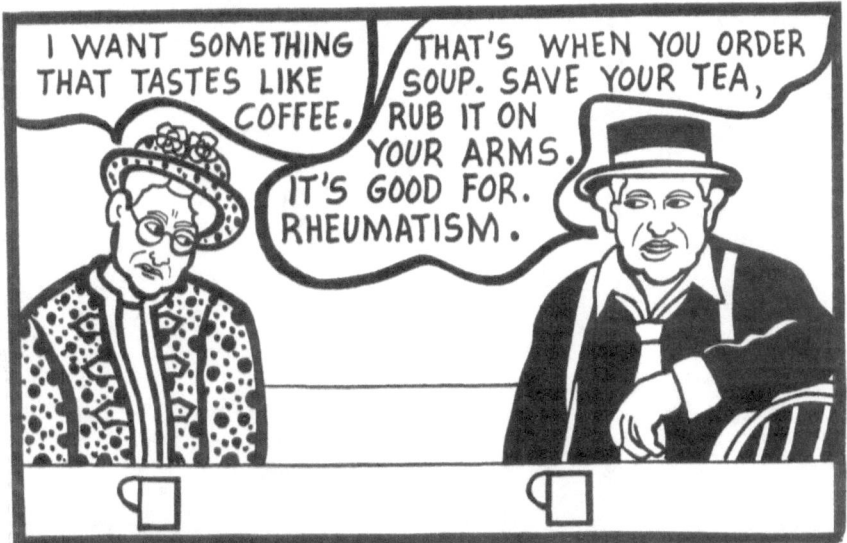

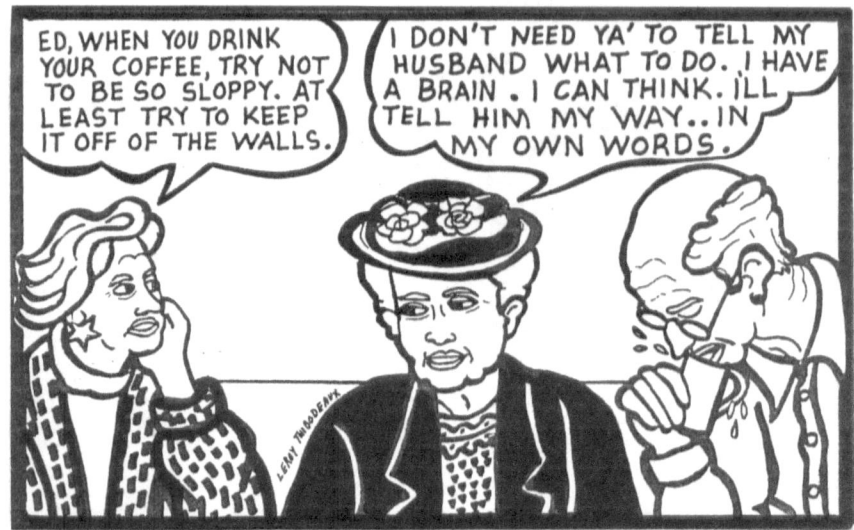
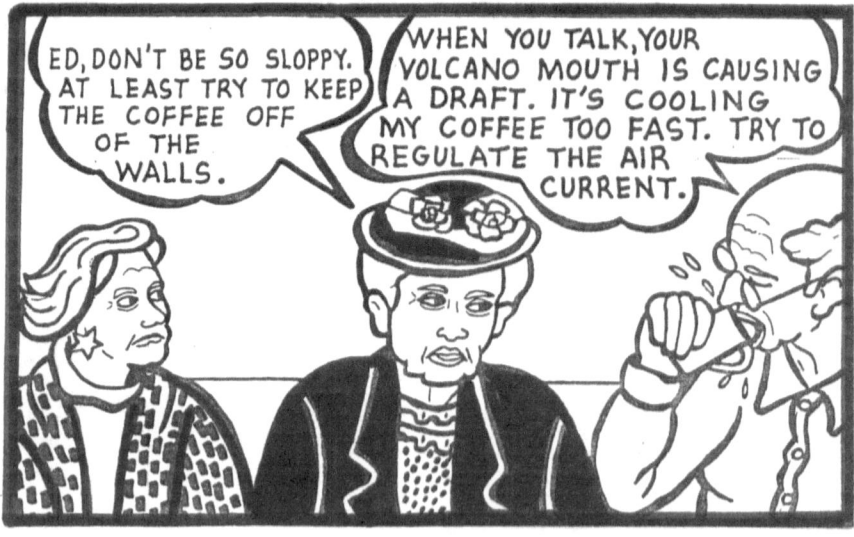

CAJUN COFFEE FOR SENIOR CITIZENS

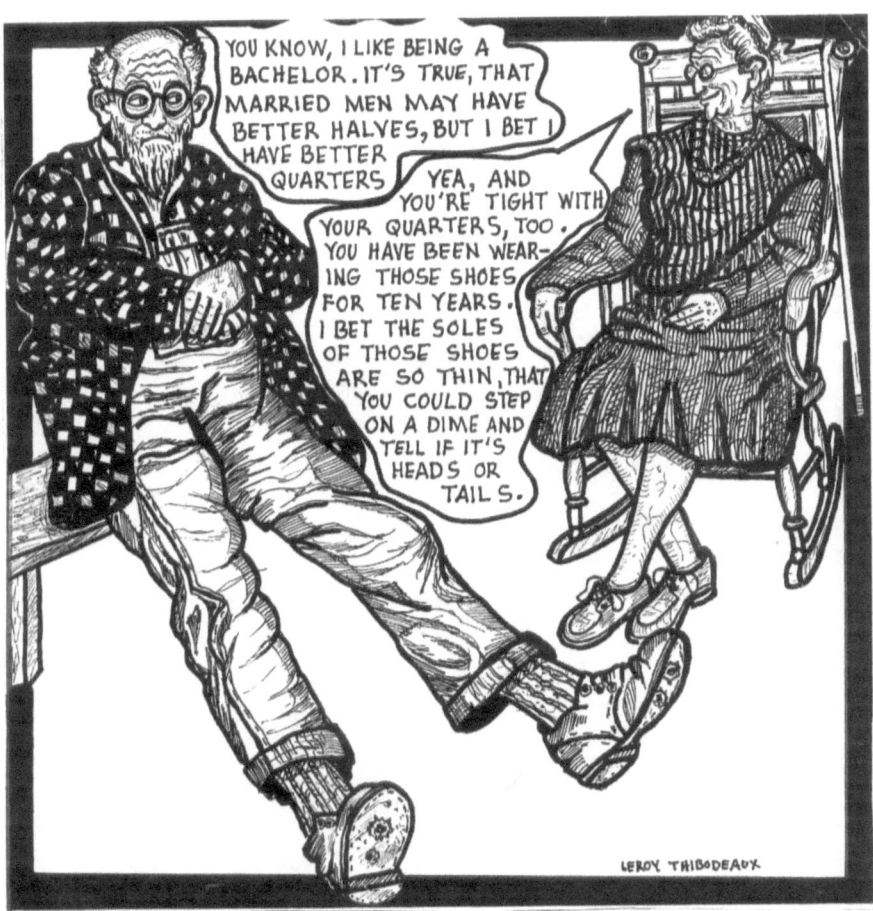

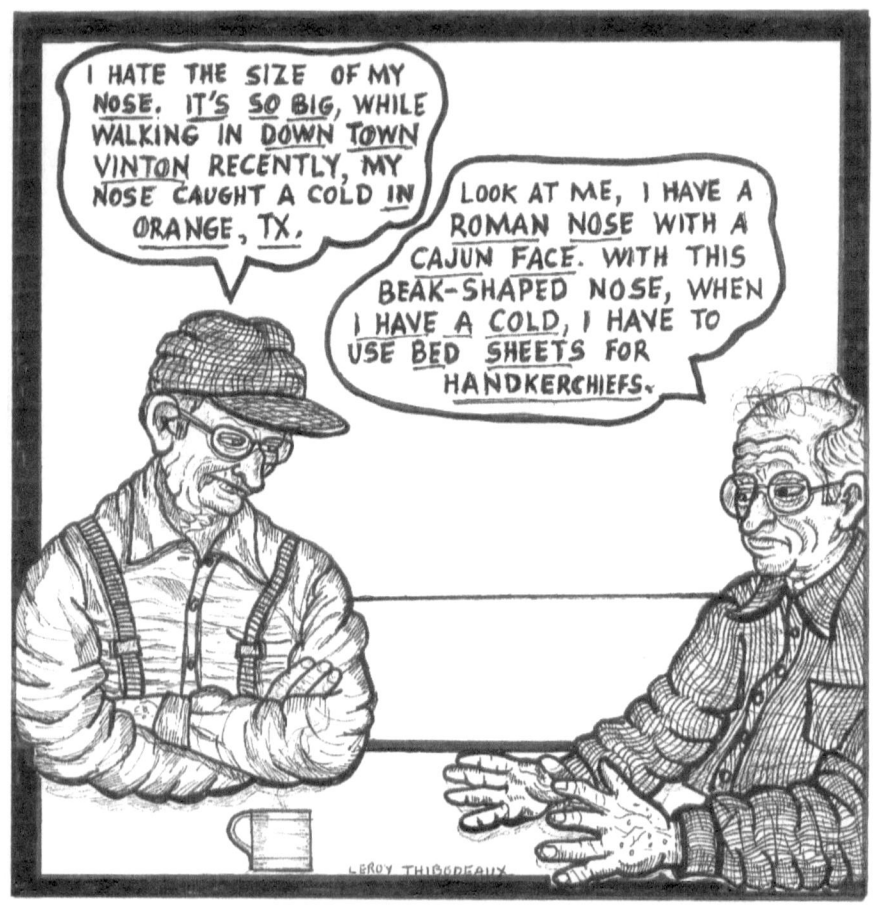

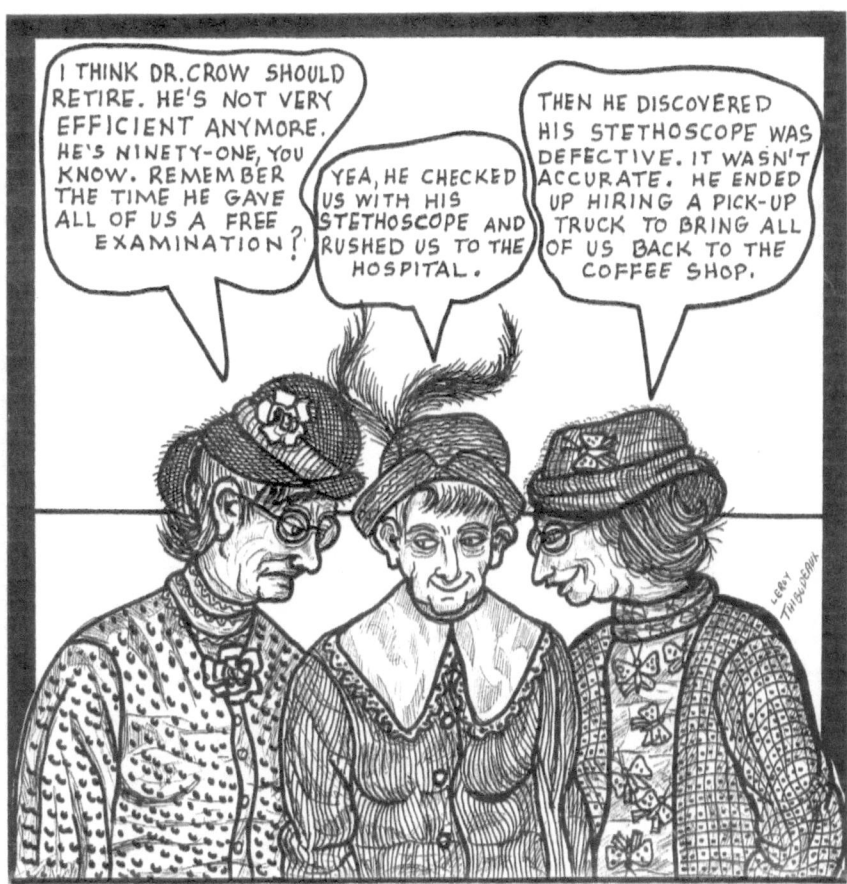

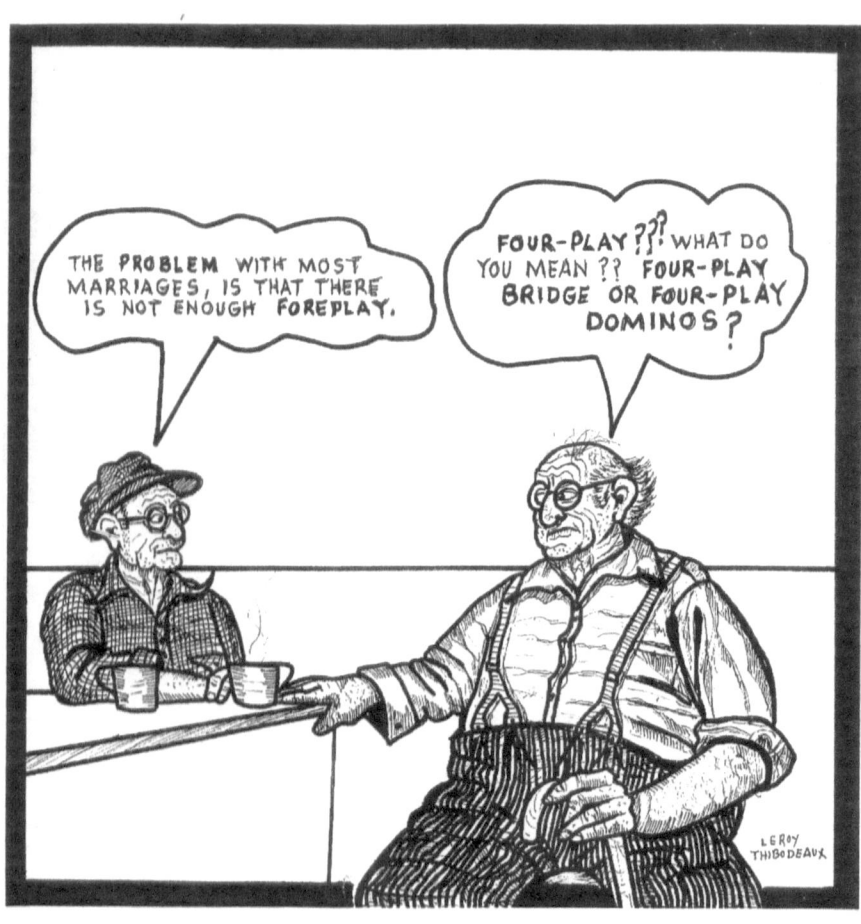

CAJUN COFFEE FOR SENIOR CITIZENS

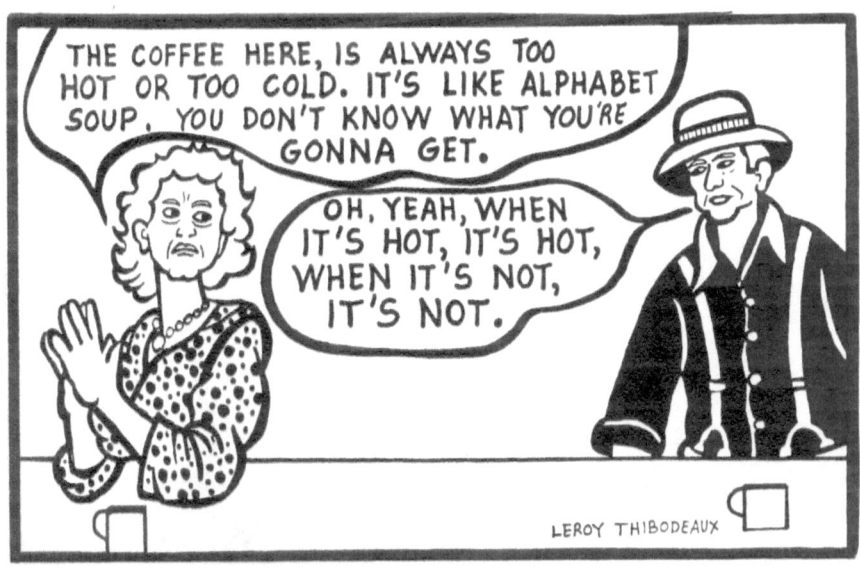

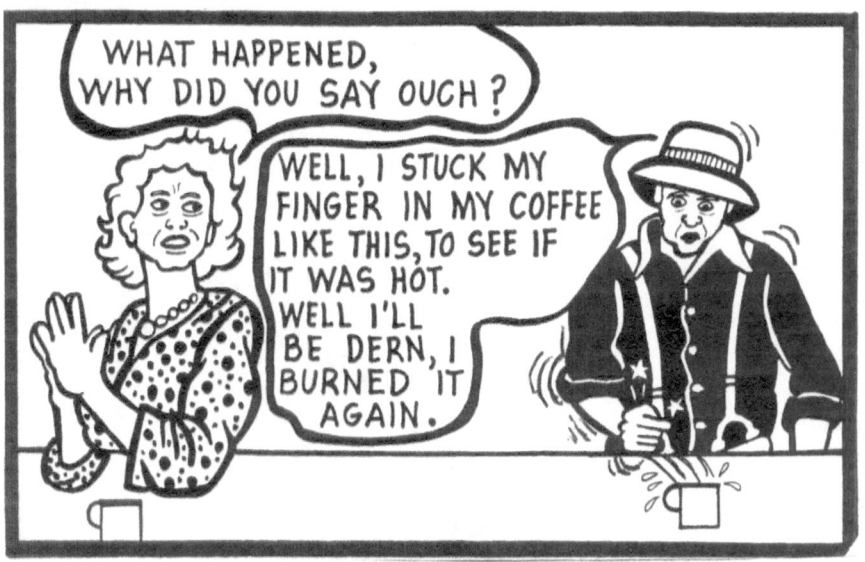

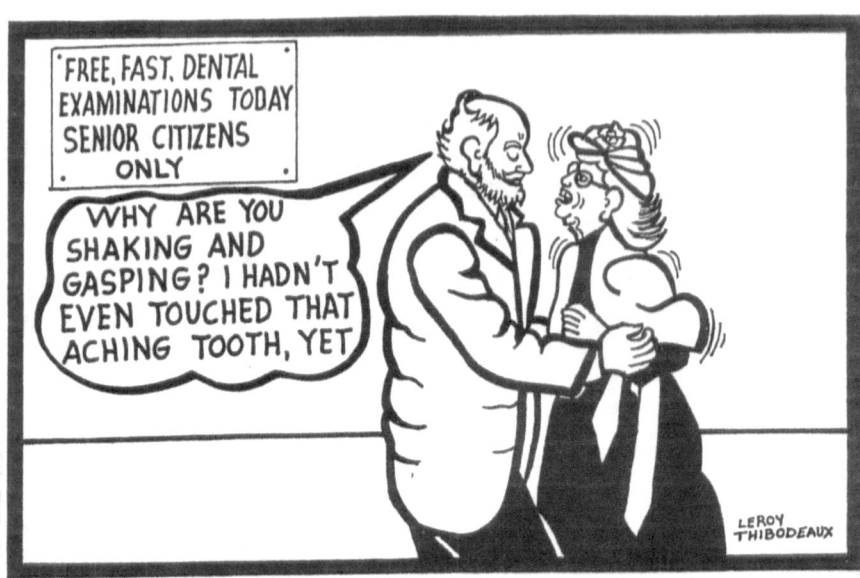
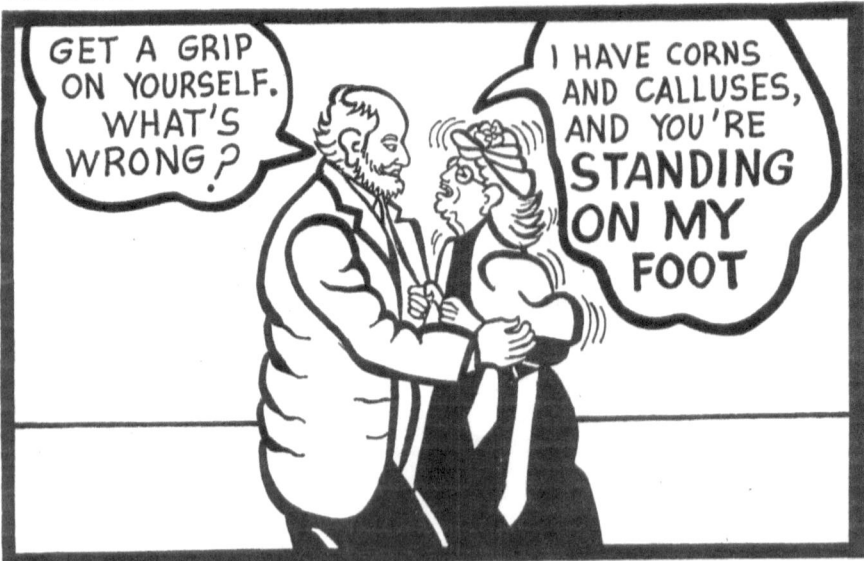

CAJUN COFFEE FOR SENIOR CITIZENS

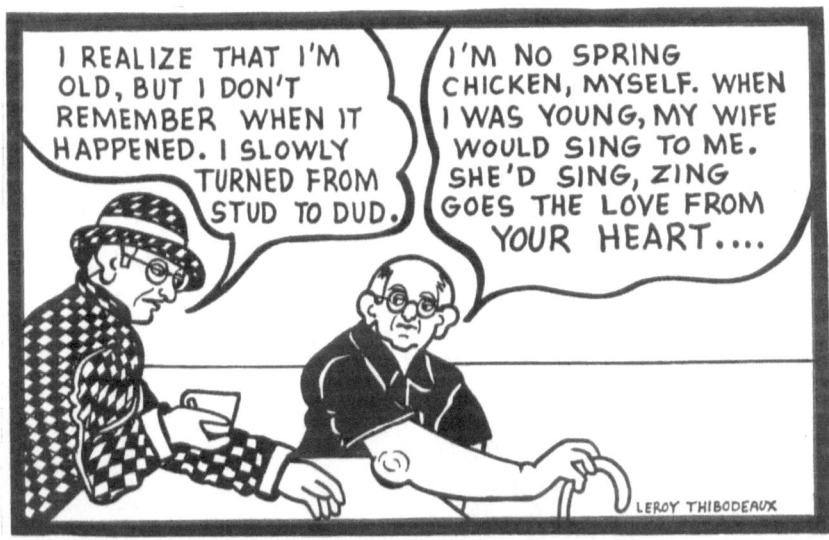

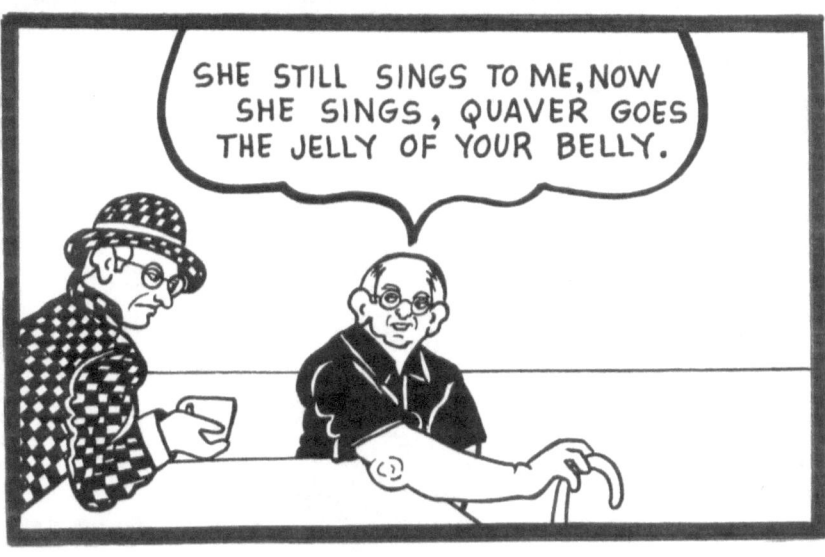

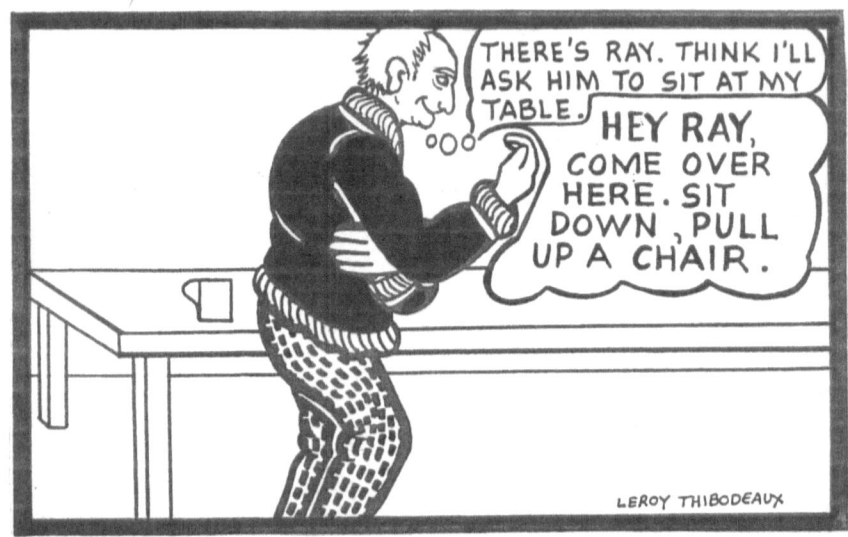
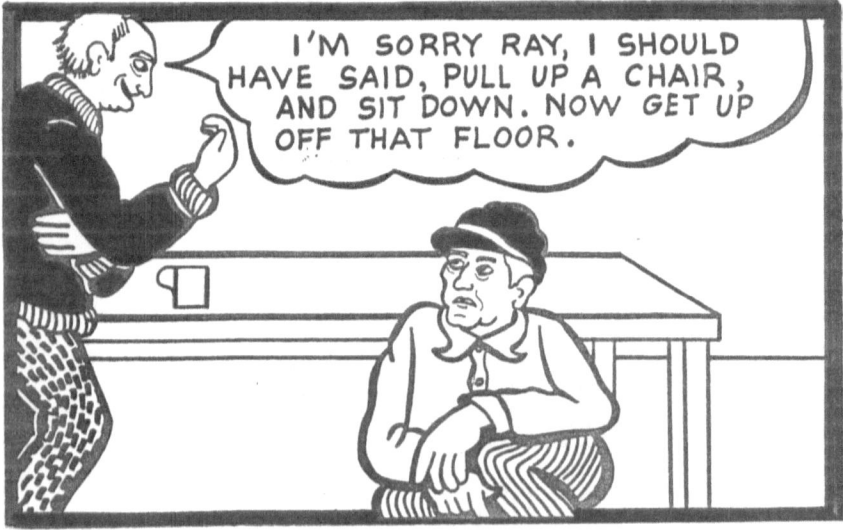

CAJUN COFFEE FOR SENIOR CITIZENS

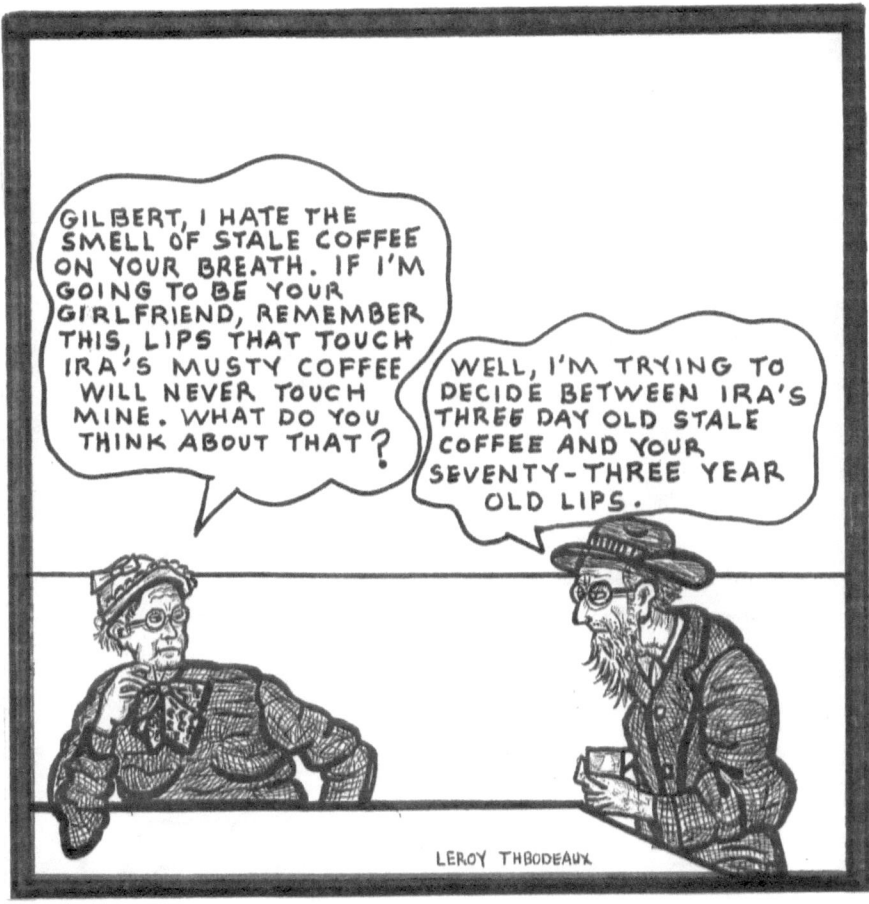

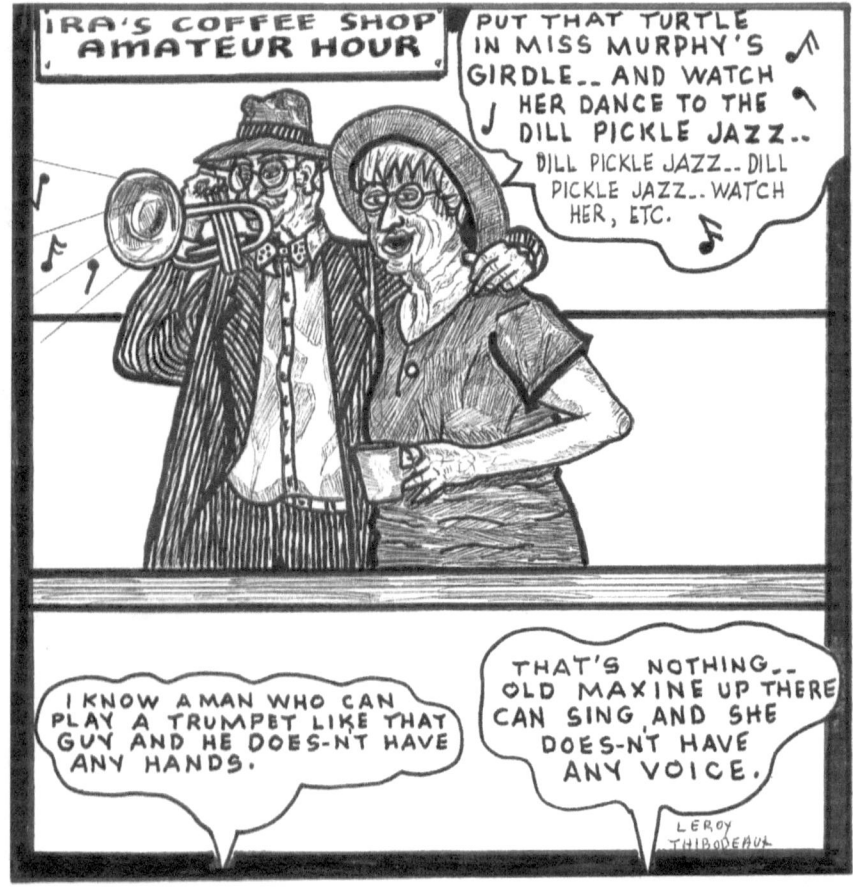

CAJUN COFFEE FOR SENIOR CITIZENS

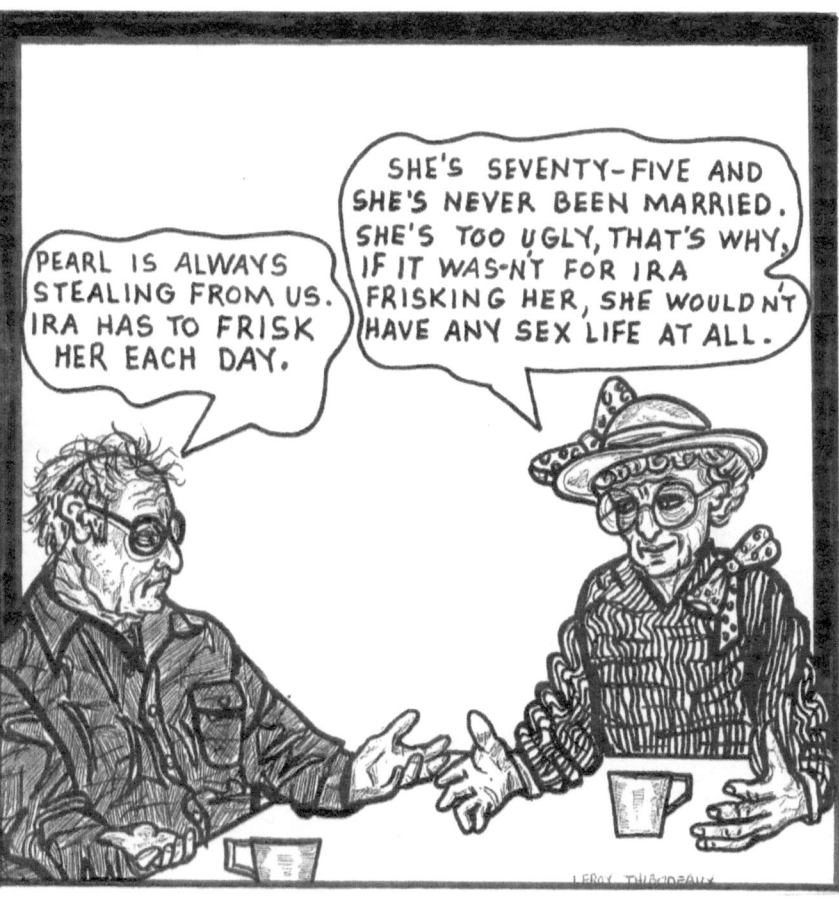

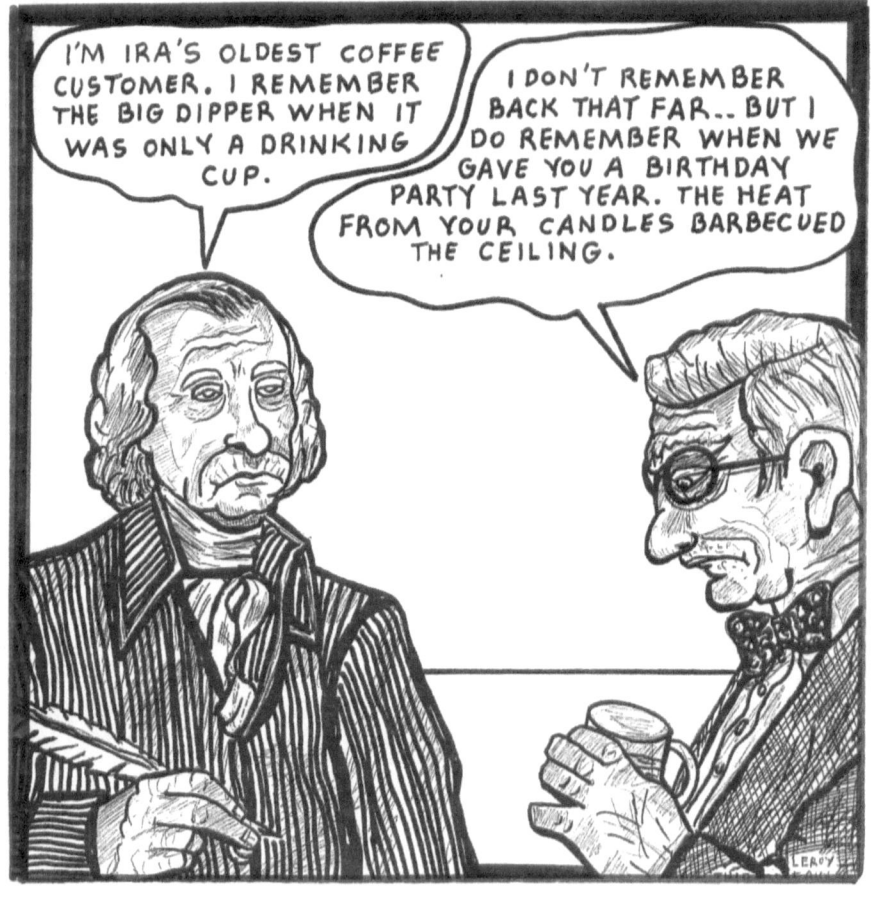

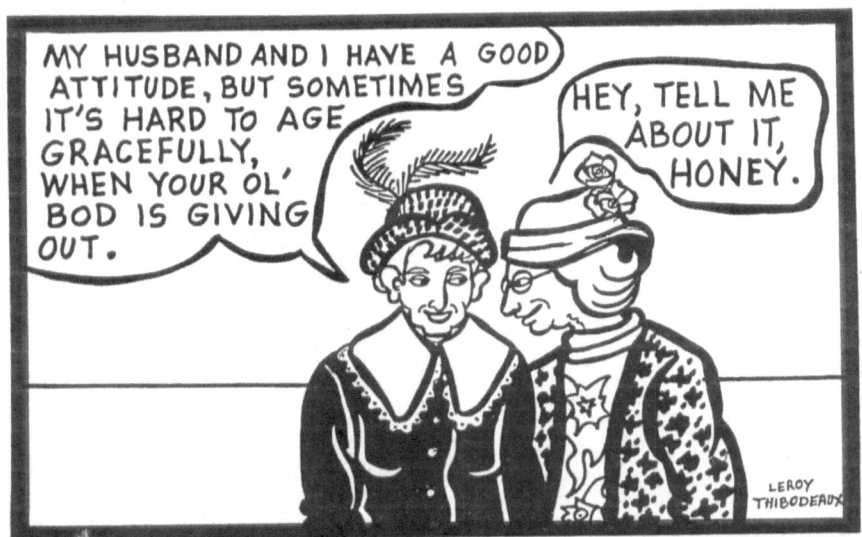
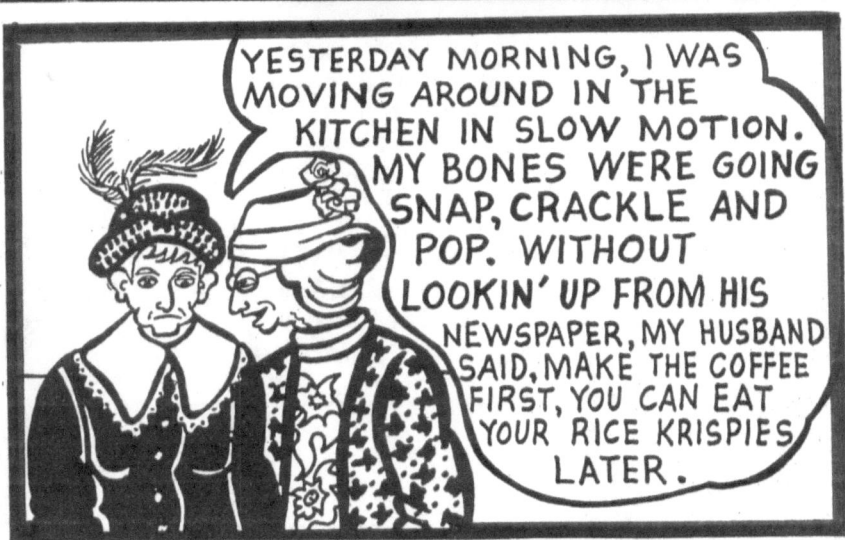

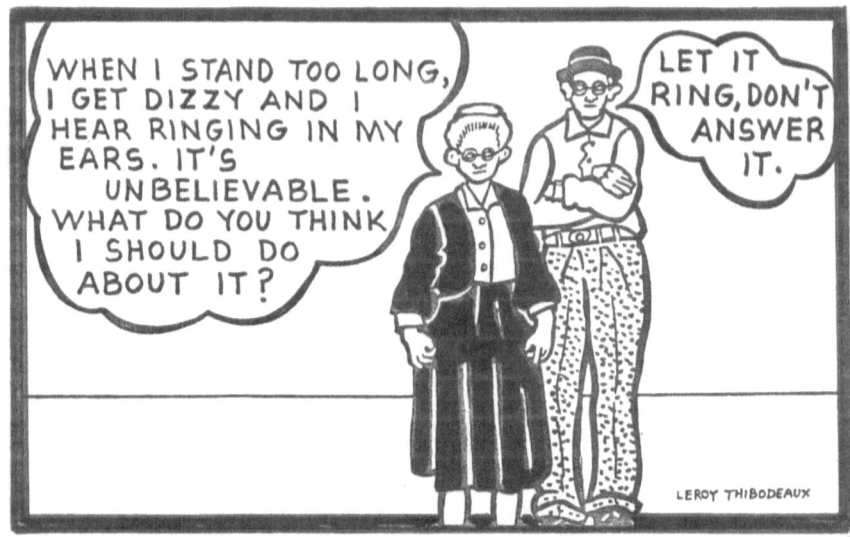
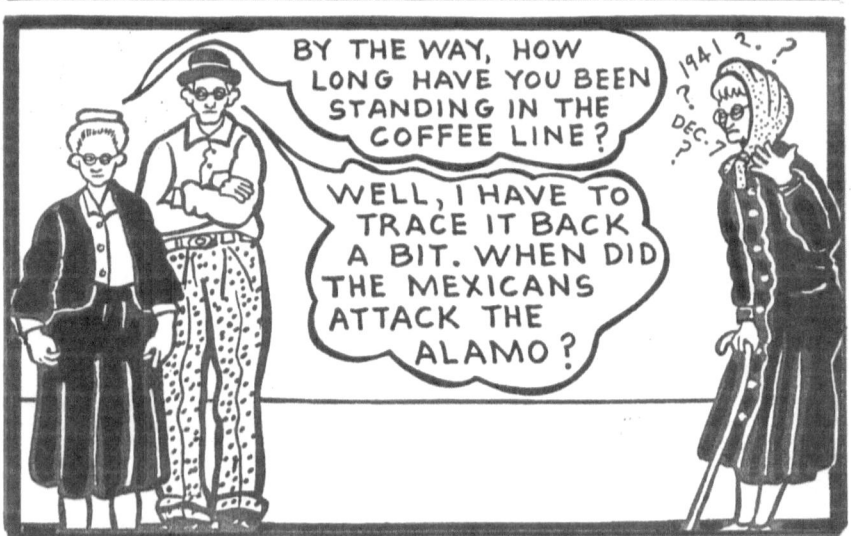

CAJUN COFFEE FOR SENIOR CITIZENS

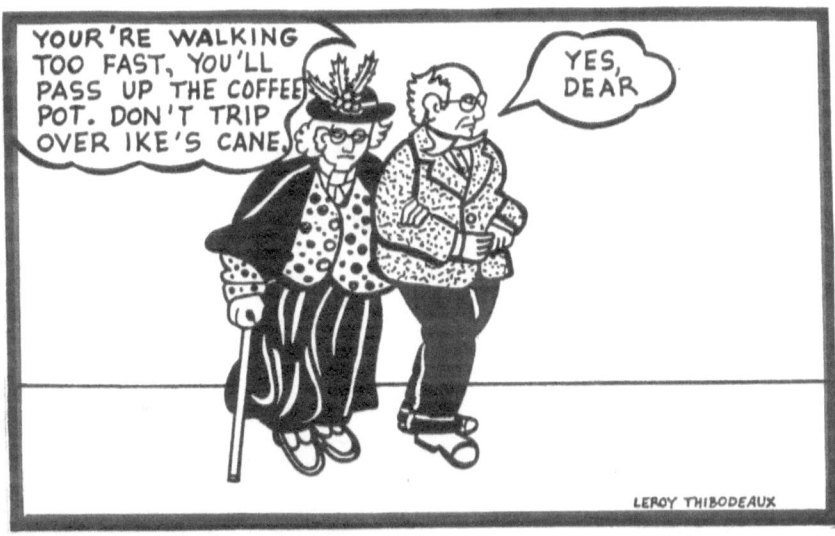

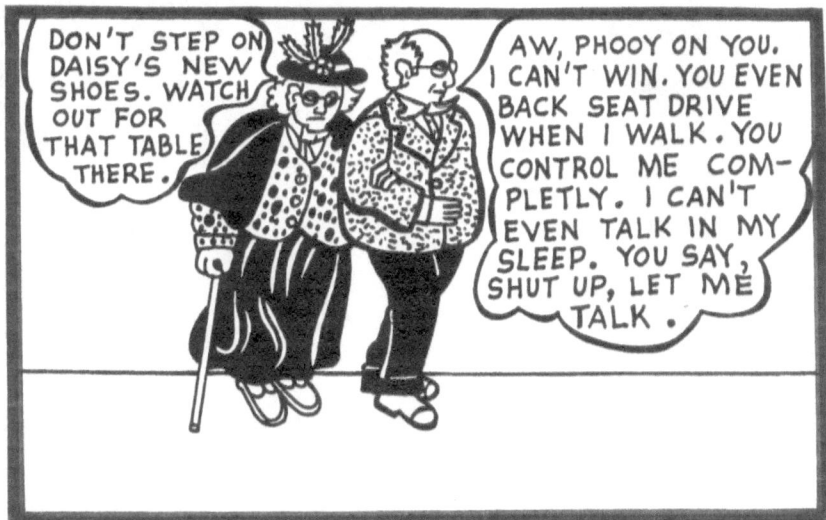

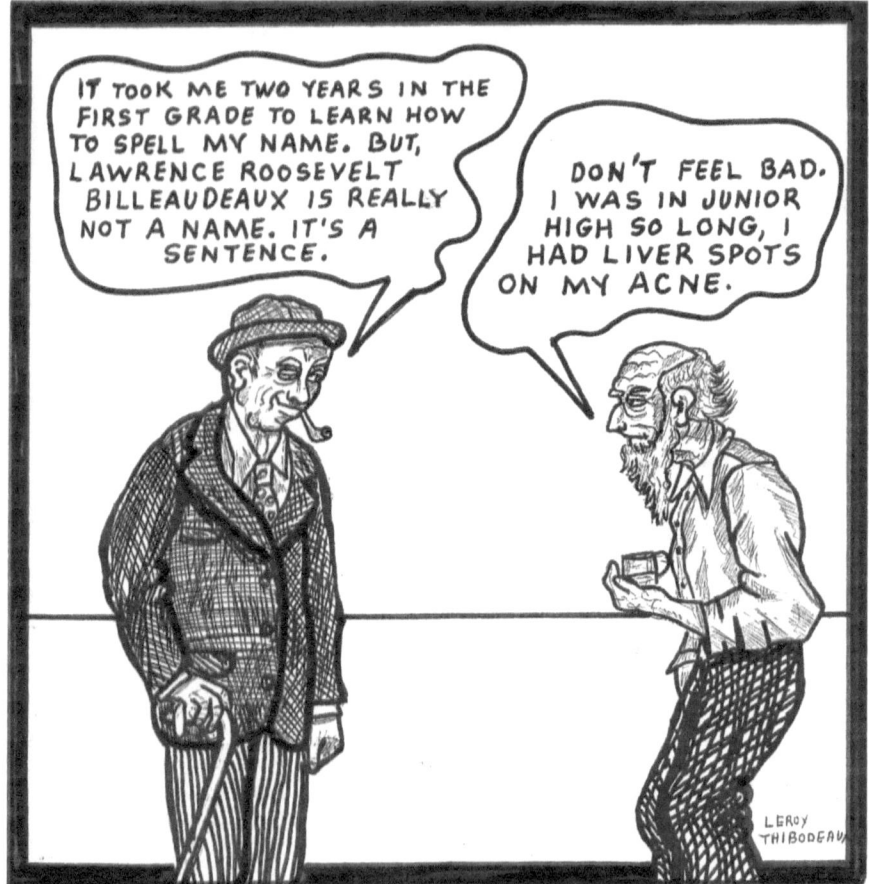

CAJUN COFFEE FOR SENIOR CITIZENS

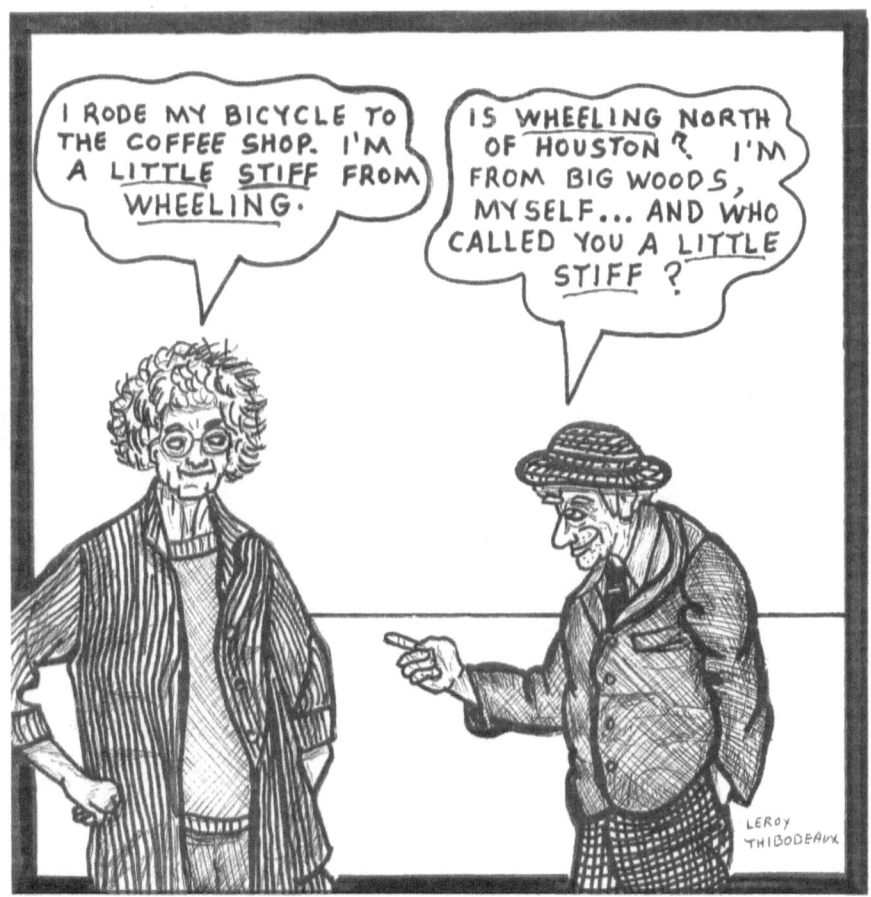

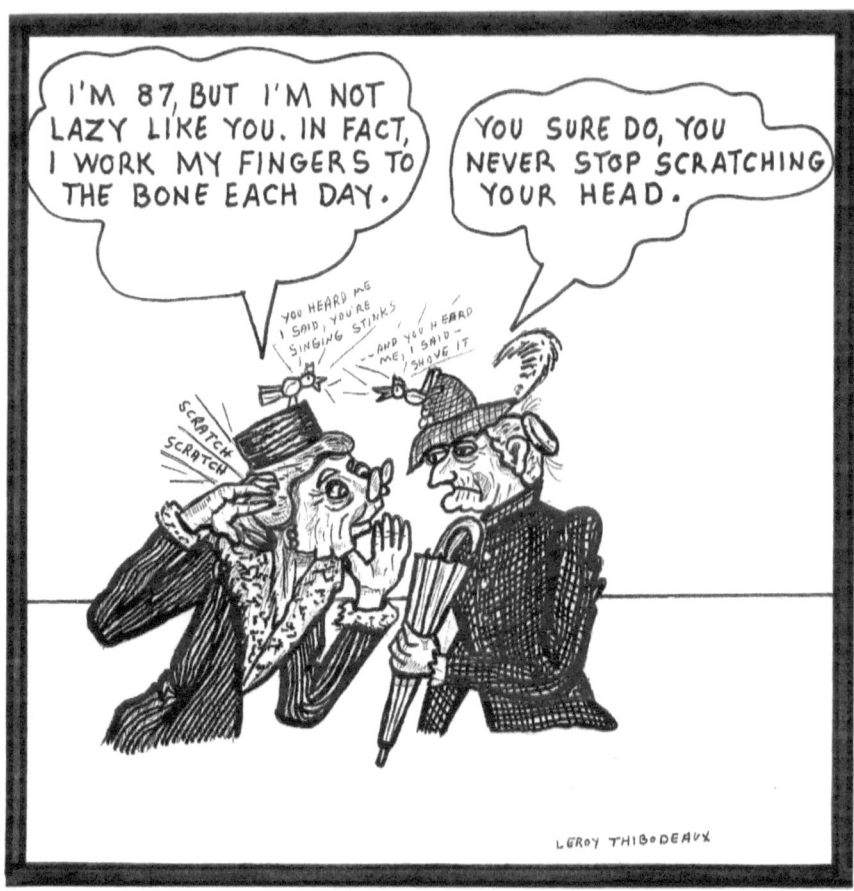

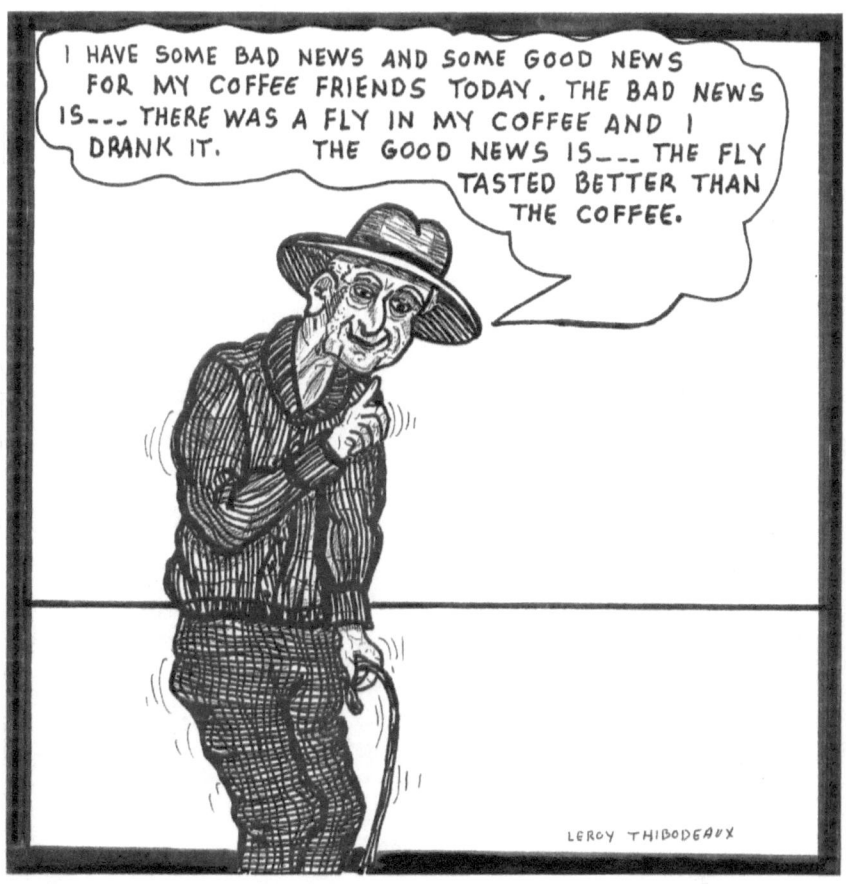

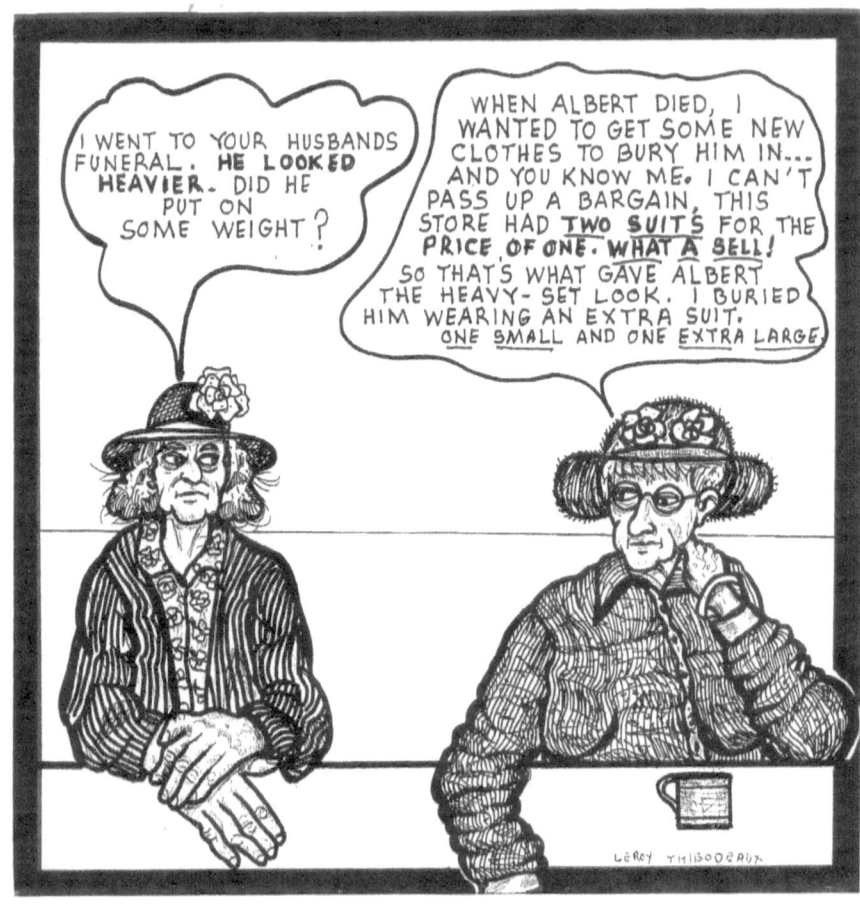

CAJUN COFFEE FOR SENIOR CITIZENS

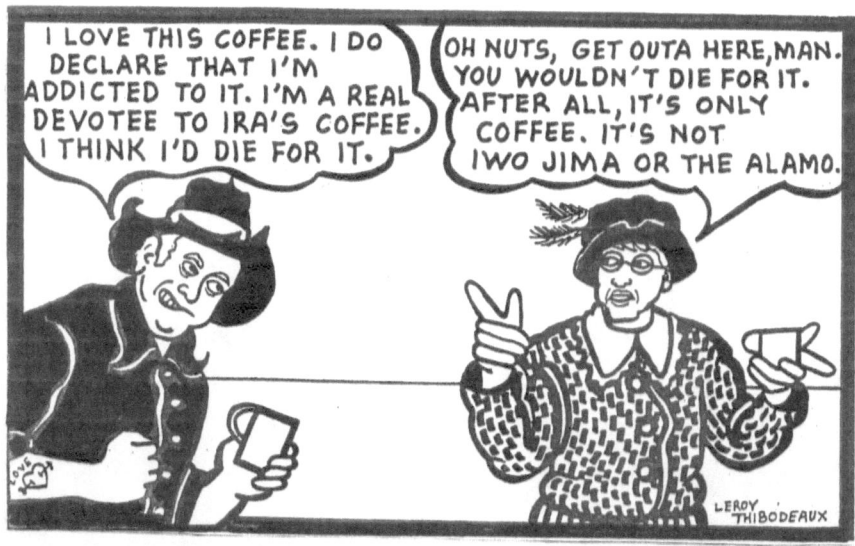

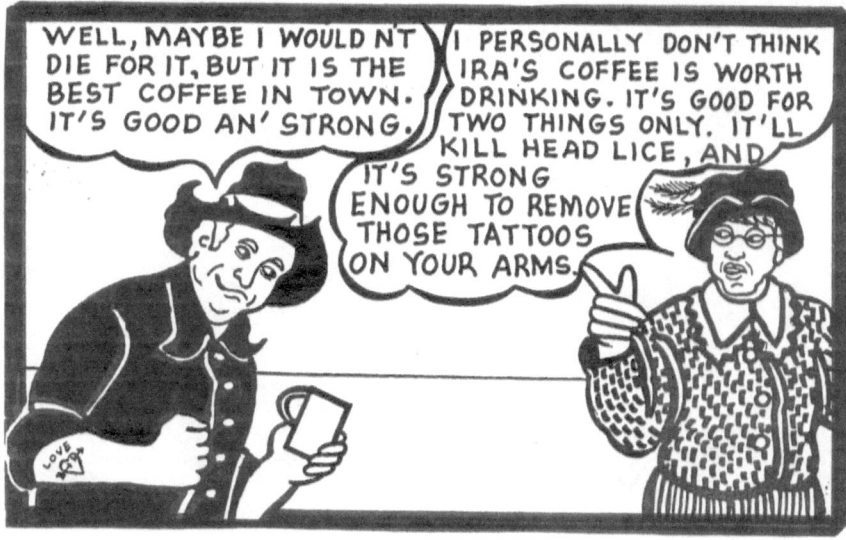

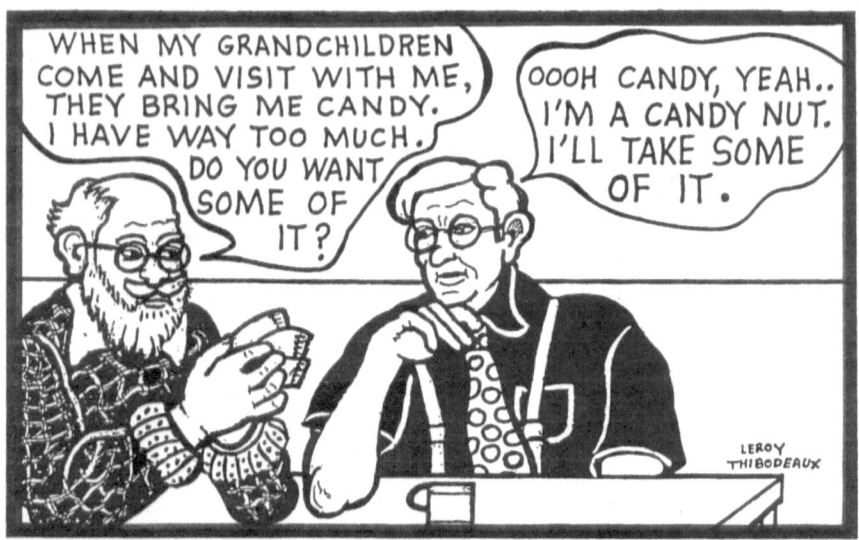
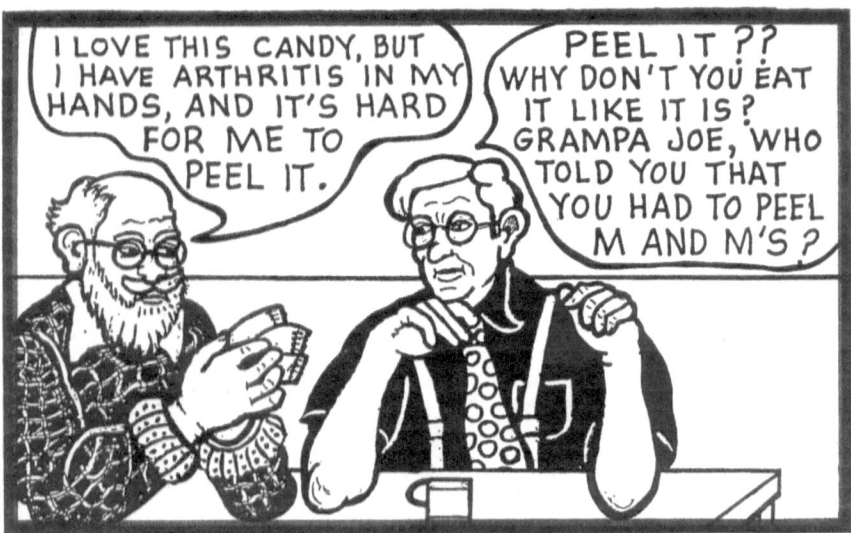

CAJUN COFFEE FOR SENIOR CITIZENS

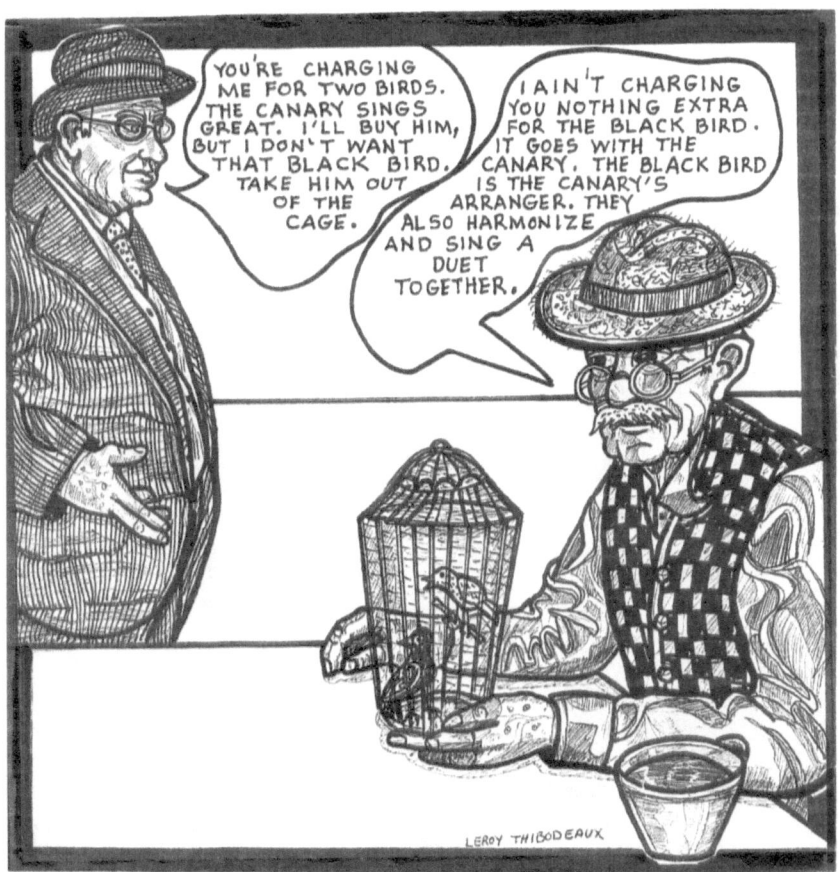

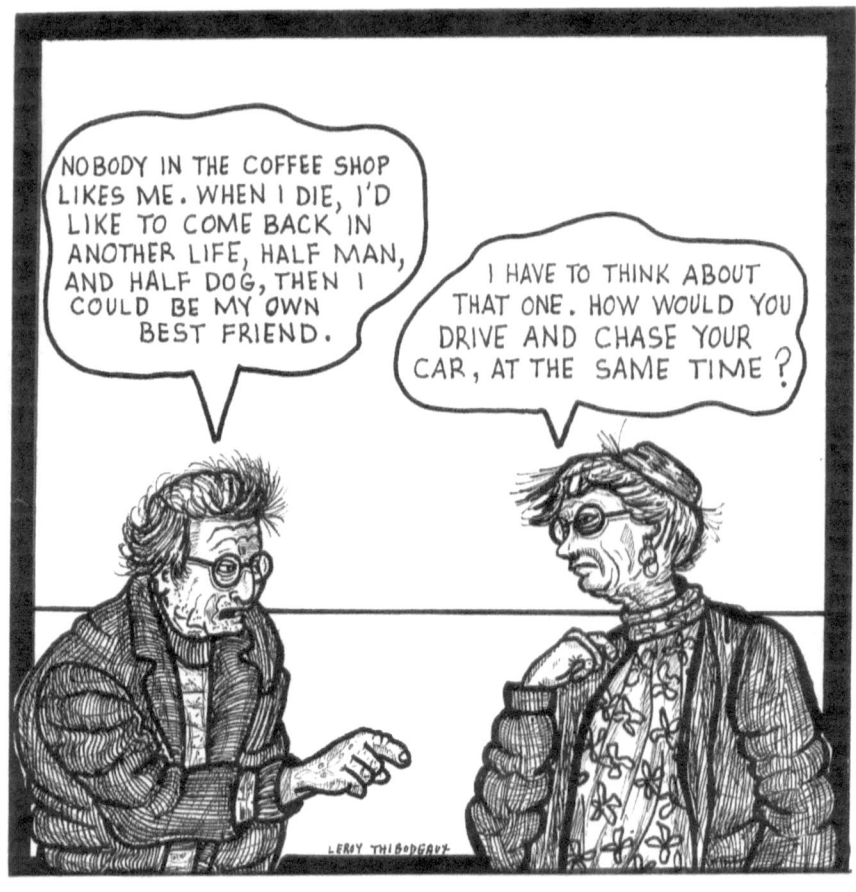

CAJUN COFFEE FOR SENIOR CITIZENS

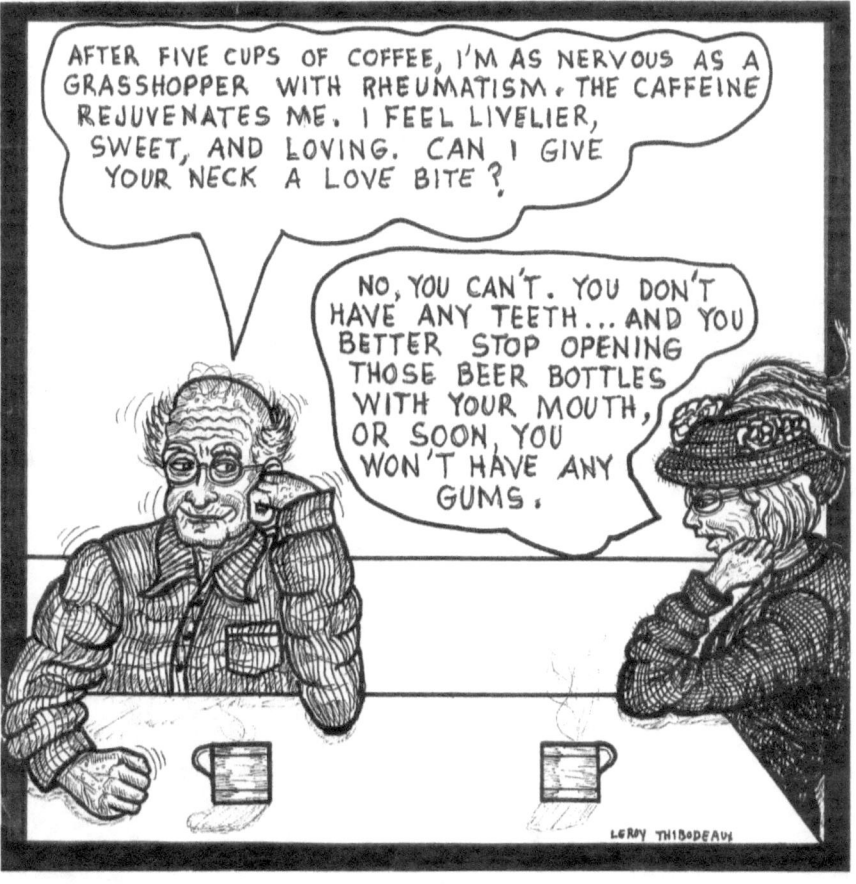

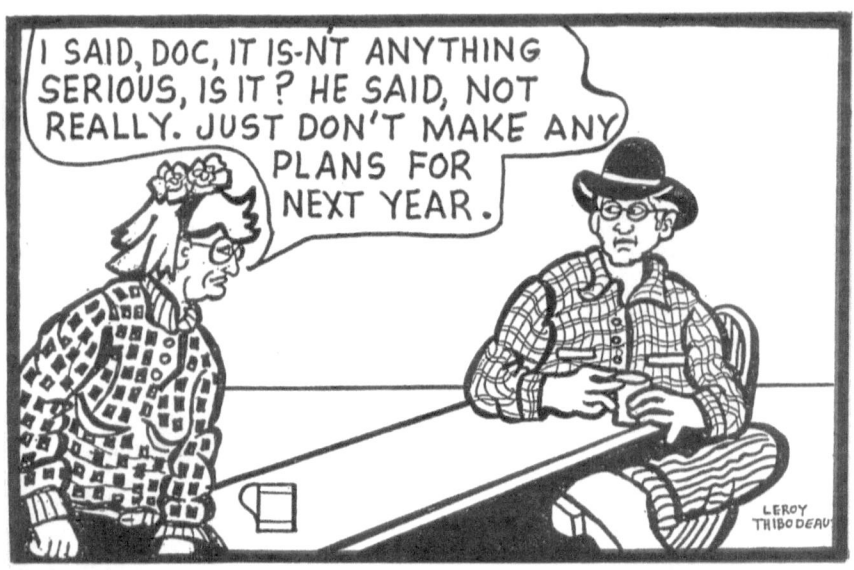
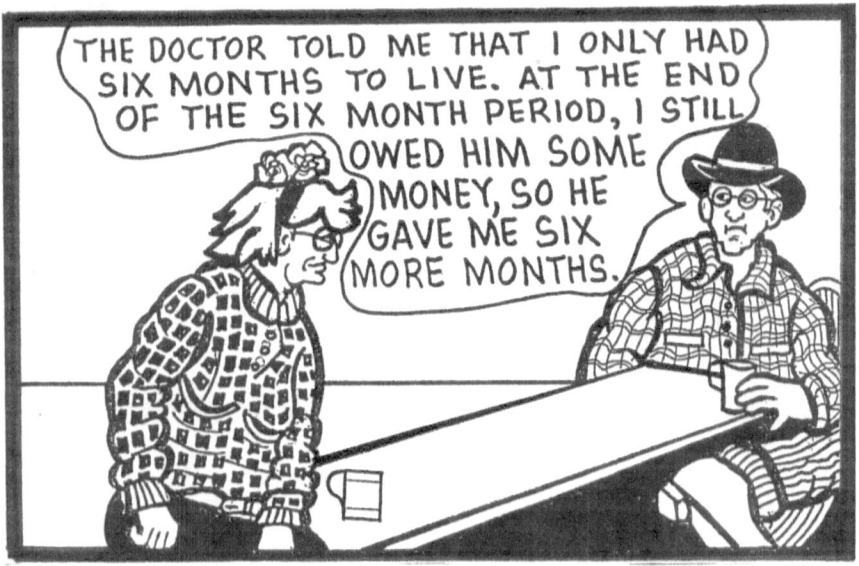

CAJUN COFFEE FOR SENIOR CITIZENS

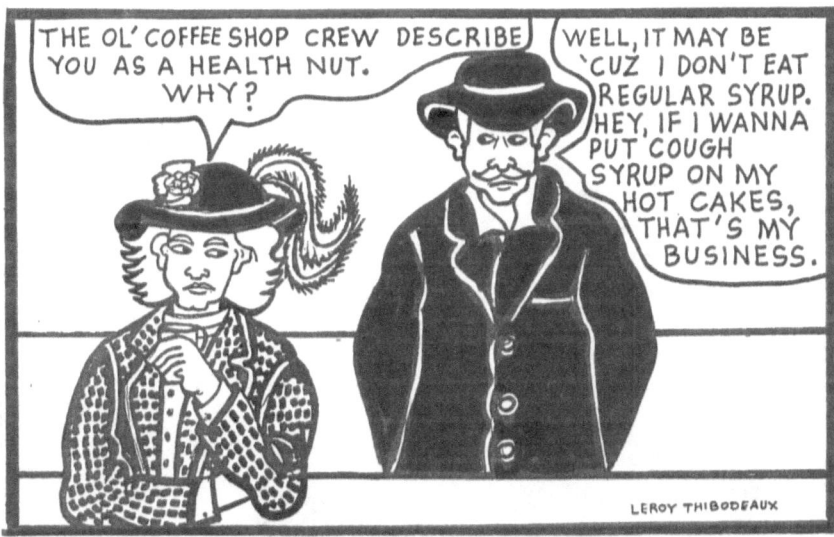

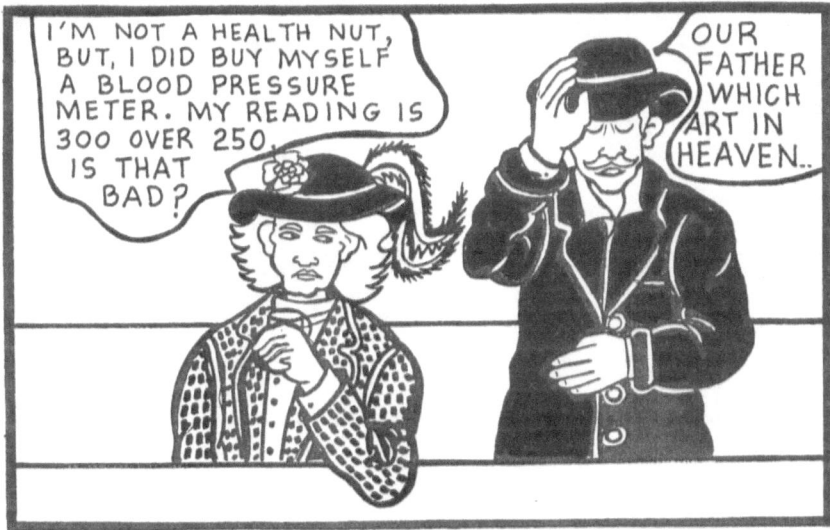

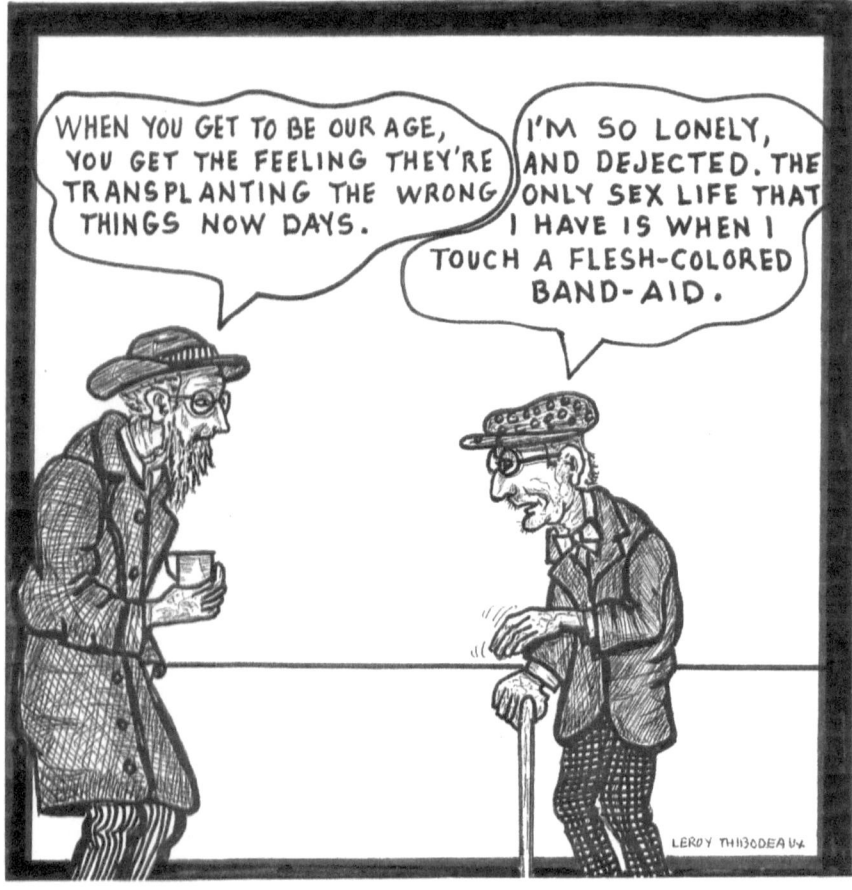

CAJUN COFFEE FOR SENIOR CITIZENS

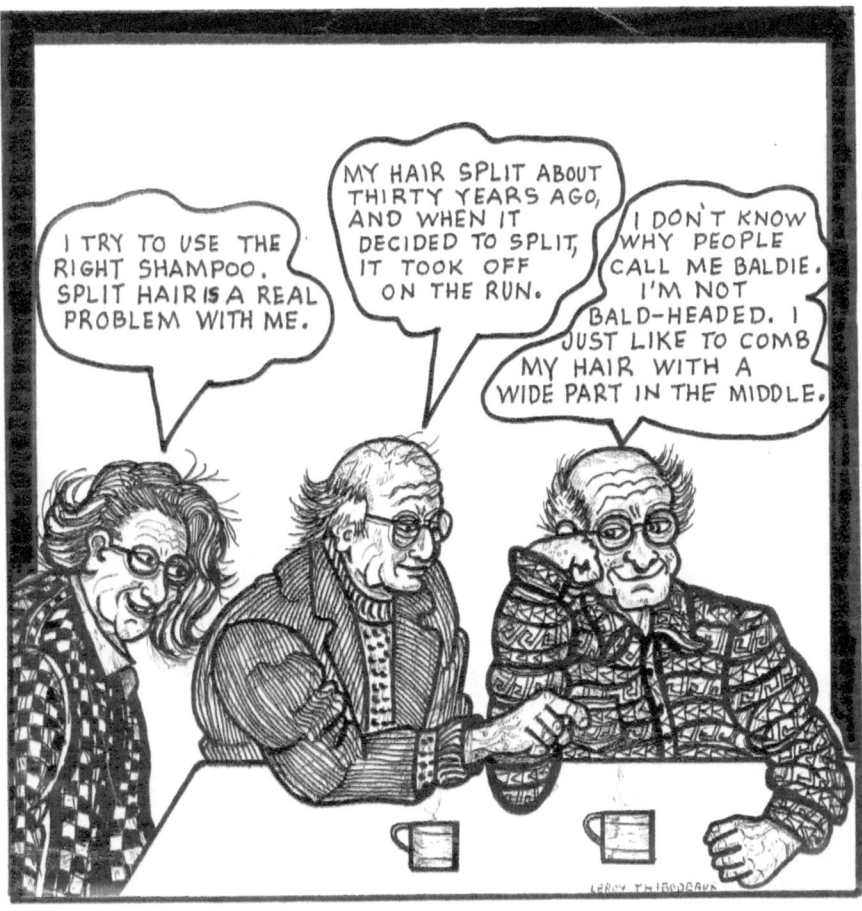

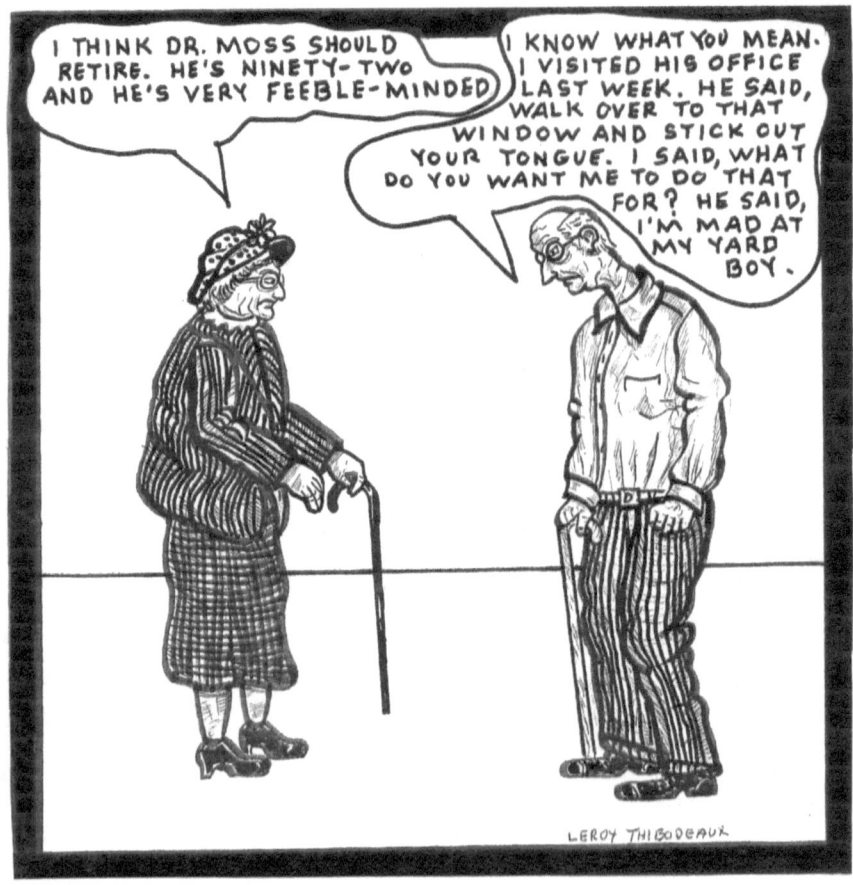

CAJUN COFFEE FOR SENIOR CITIZENS

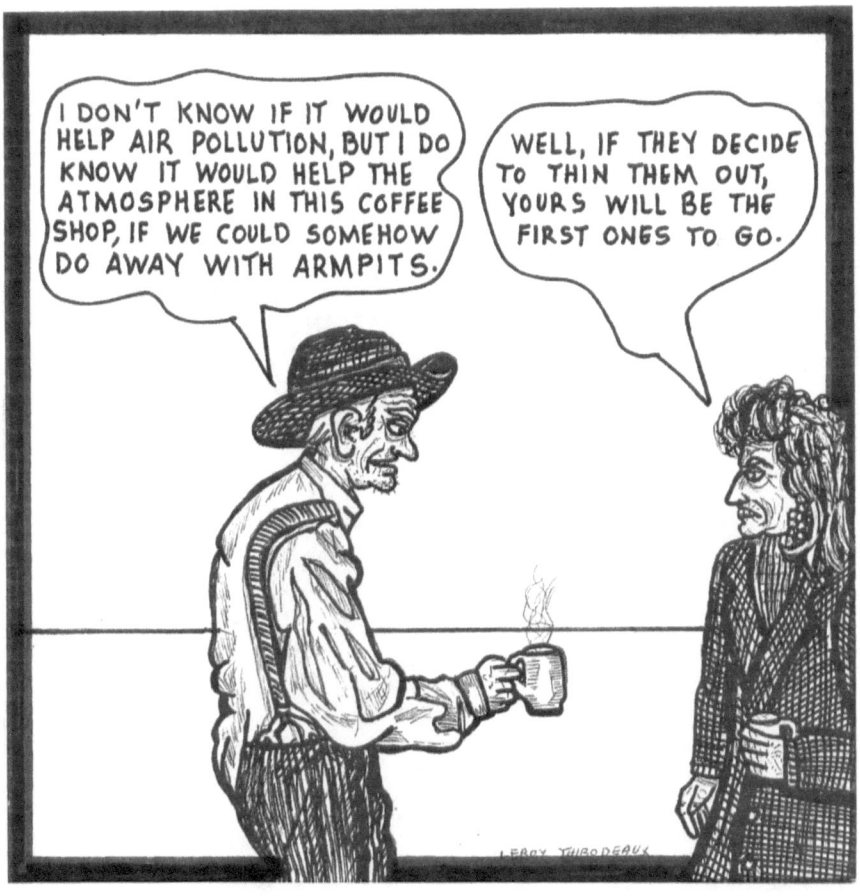

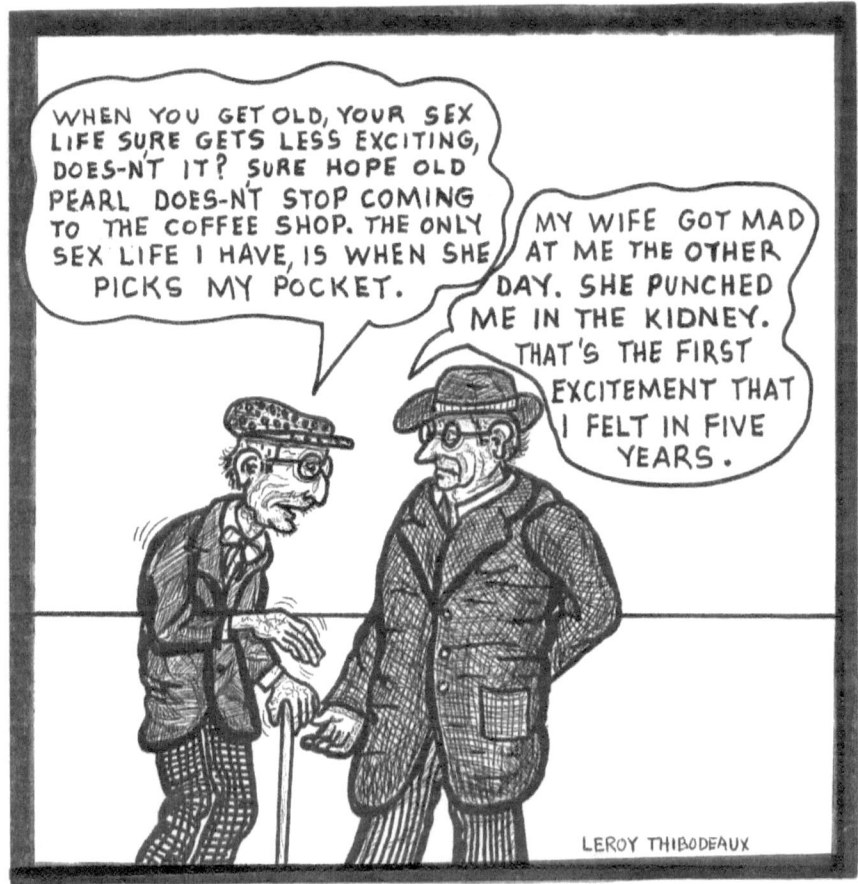

CAJUN COFFEE FOR SENIOR CITIZENS

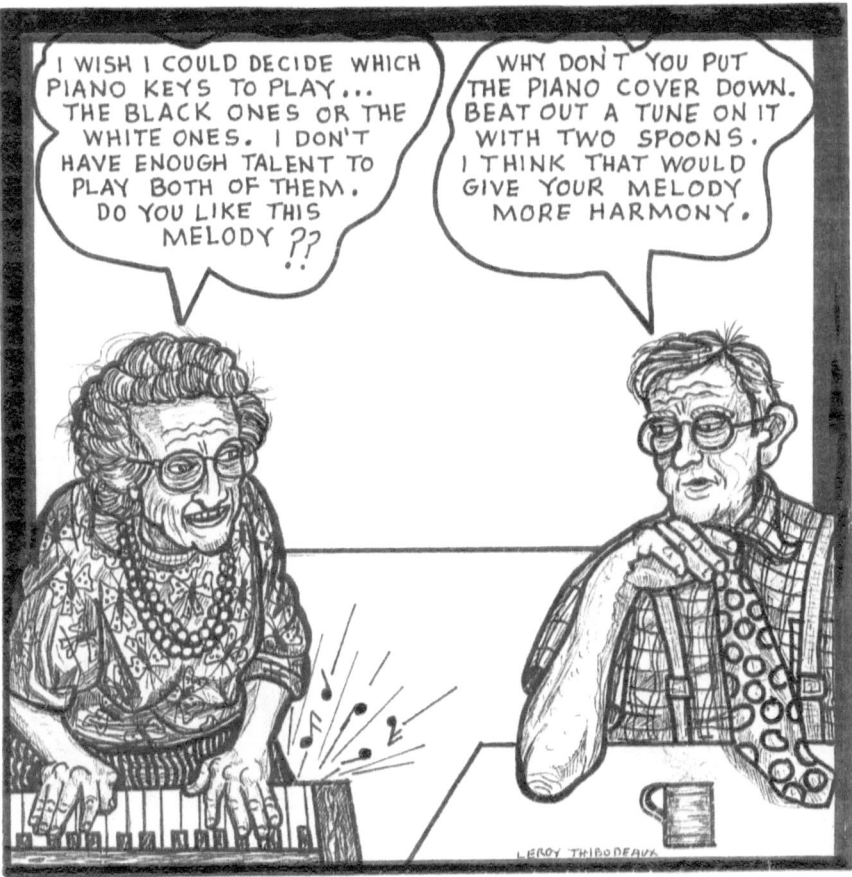

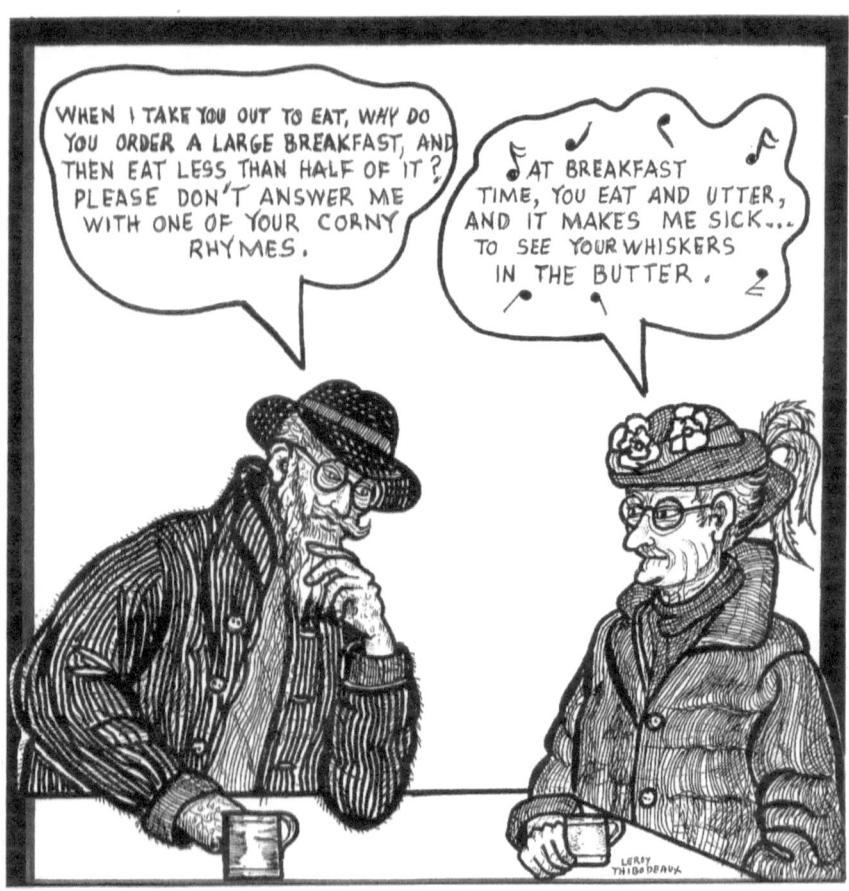

CAJUN COFFEE FOR SENIOR CITIZENS

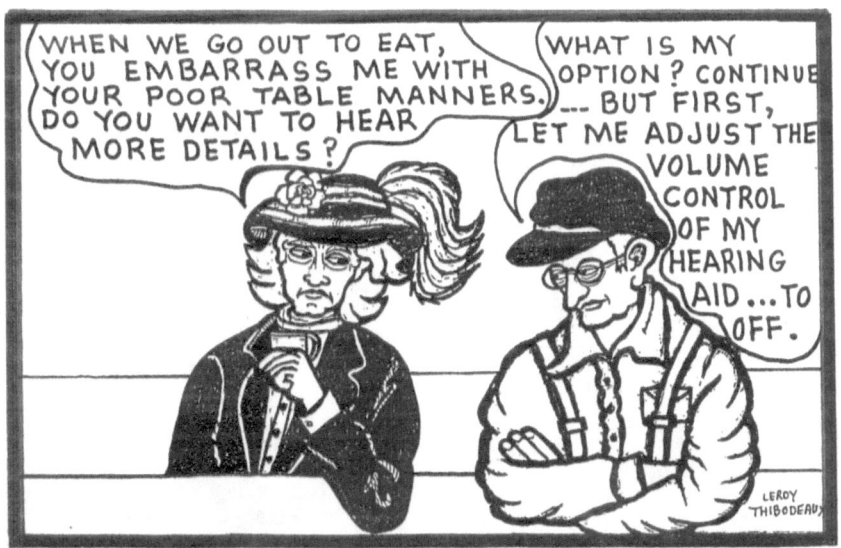

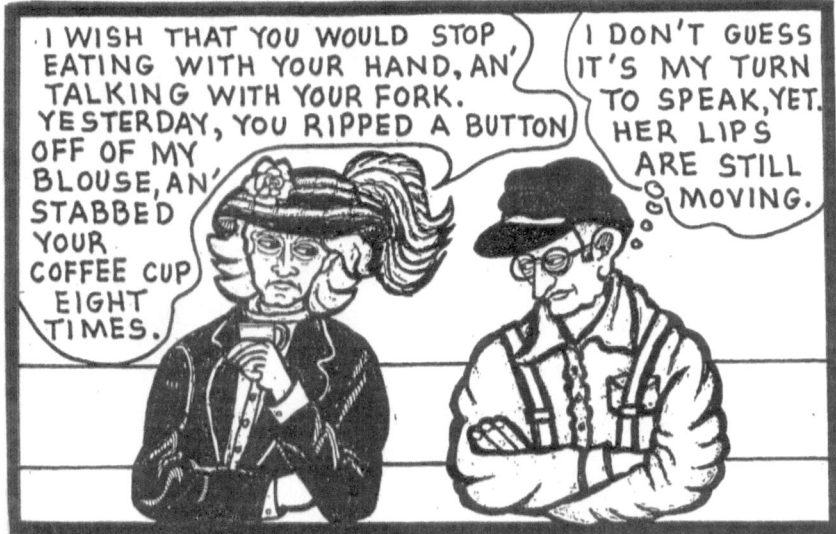

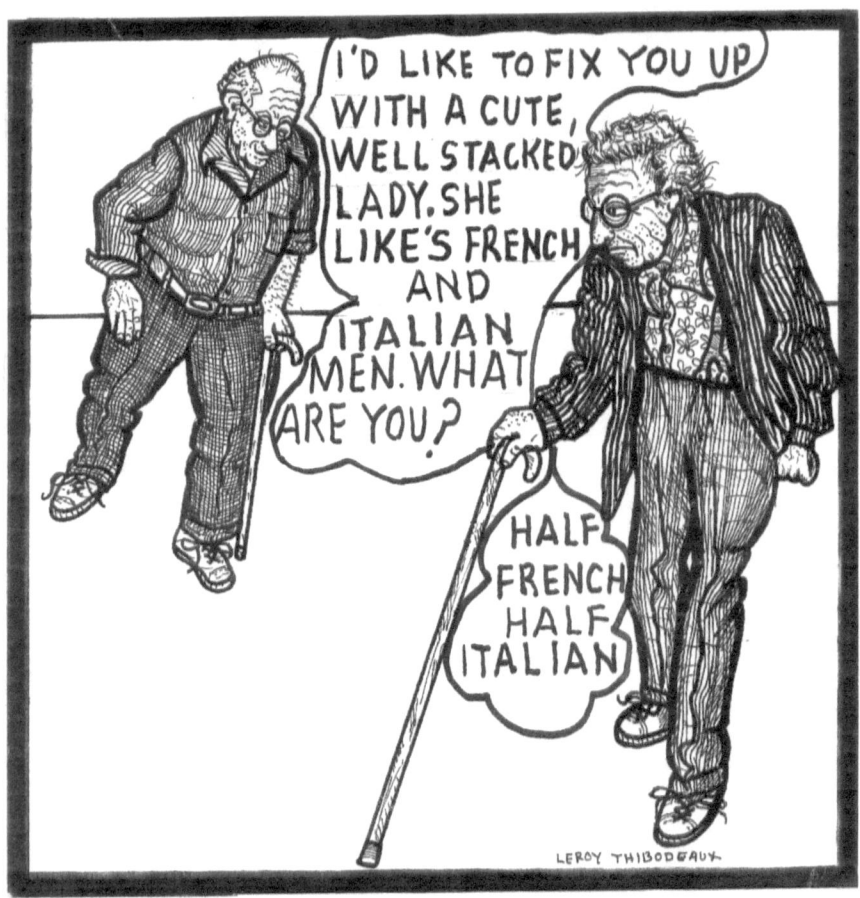

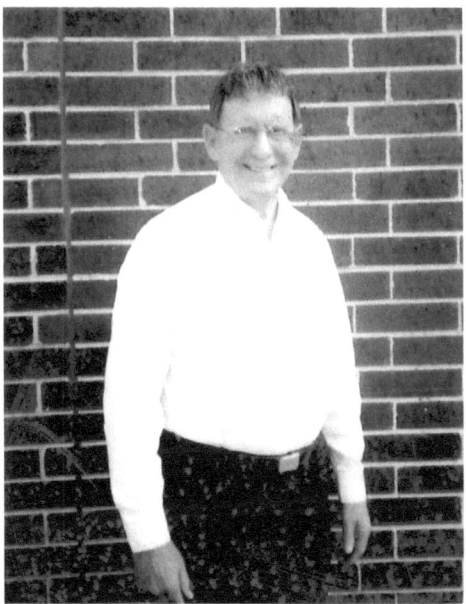

ABOUT THE ARTIST

Leroy Thibodeaux was born in Vinton, Louisiana. He graduated from Vinton High School, in the ensuing years, he studied art for two years and has a Certification of Graduation in Cartooning.

He was employed by Ashland Oil, Inc., Levingston Shipbuilding, from 1972 to 1982 as a cartoonist and sign painter. His duties included creating safety posters, adding cartoons and illustrations with sign work. The response to the humorous safety posters were overwhelmingly successful. He gained a measure of fame by being featured in the internationally circulated "Ashland News", a publication of Ashland Oil, inc. The story depicted photographs of himself and cartoon safety posters that he created.

He was recognized in 1976 by Ashland Oil Company as the person who did more to promote safety out of more than 50,000 employees throughout the corporation. His interest and the originality of his "Cartoon" safety posters were the main factors in Leroy being selected.

Leroy is now a self-employed artist. He paints Cajuns' and Creoles' "Doing Their Thing"

www.ingramcontent.com/pod-product-compliance
Lightning Source LLC
Chambersburg PA
CBHW022119170526
45157CB00004B/1696